DRAW baby animals

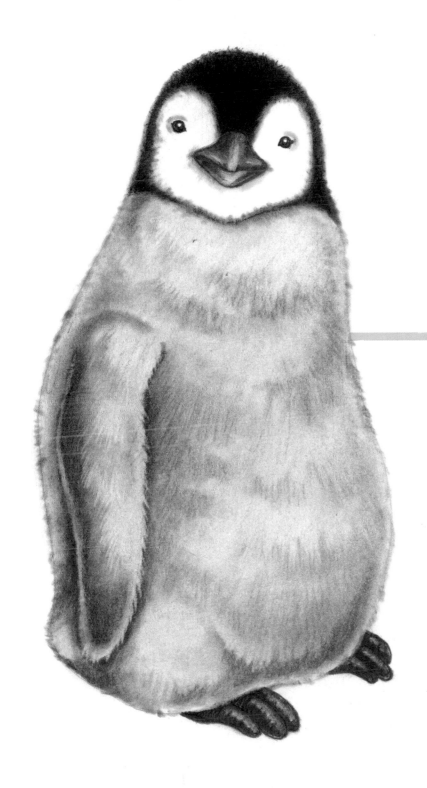

Jane Maday

NORTH LIGHT BOOKS
CINCINNATI, OHIO
www.artistsnetwork.com

Draw Baby Animals. COPYRIGHT © 2009 BY JANE MADAY. Manufactured in the U.S.A. All rights reserved. No part of this book may be reproduced in any form or by any electronic or mechanical means including information storage and retrieval systems without permission in writing from the publisher, except by a reviewer who may quote brief passages in a review. Published by North Light Books, an imprint of F+W Media, Inc., 4700 East Galbraith Road, Cincinnati, Ohio, 45236. (800) 289-0963. First Edition.

Other fine North Light Books are available from your local bookstore, art supply store or online supplier. Visit our website at www.fwmedia.com.

20 19 18 17 16 13 12 11 10

DISTRIBUTED IN CANADA BY FRASER DIRECT
100 Armstrong Avenue, Georgetown, ON, Canada L7G 5S4
Tel: (905) 877-4411

DISTRIBUTED IN THE U.K. AND EUROPE BY DAVID & CHARLES
Brunel House, Newton Abbot, Devon, TQ12 4PU, England
Tel: (+44) 1626 323200, Fax: (+44) 1626 323319
Email: postmaster@davidandcharles.co.uk

DISTRIBUTED IN AUSTRALIA BY CAPRICORN LINK
P.O. Box 704, S. Windsor NSW, 2756 Australia
Tel: (02) 4577-3555

Library of Congress Cataloging-in-Publication Data
Maday, Jane.
 Draw baby animals / Jane Maday.
 p. cm.
 Includes index.
 ISBN 978-1-60061-195-7 (pbk. : alk. paper)
 1. Animals in art. [1. Drawing--Technique.] I. Title.
 NC780.M24 2009
 743.6--dc22
 2008052770

EDITED BY **Erika O'Connell** & **Kathy Kipp**
DESIGNED BY **Jennifer Hoffman**
PAGE LAYOUT BY **Lauren Yusko**
PRODUCTION COORDINATED BY **Matt Wagner**

About the Author

Born in England and raised in the United States, Jane Maday has been a professional artist since she was fourteen years old. At sixteen, she was hired as a scientific illustrator at the University of Florida. After graduating from the Ringling College of Art and Design, she was recruited by Hallmark Cards, Inc., as a greeting card illustrator. She left the corporate world after her children were born and now licenses her work for numerous products such as cards, puzzles, needlework kits and T-shirts. Jane also writes art instruction books and articles. She is the author of *Adorable Animals You Can Paint*, *Cute Country Animals You Can Paint* and *Landscapes in Bloom* (all from North Light Books). Jane lives in scenic Colorado with her husband and two children and a menagerie of animals. You can see more of her work or contact her through her website, www.janemaday.com.

Acknowledgments

I would like to thank several people for helping to make this book possible. First, thanks to Diane at Lakeland Animal Shelter in Elkhorn, Wisconsin, for her help with kitten and puppy photos. Thanks also to Sharon Eide and Elisabeth Flynn for help with farm animal photos, and to Dave Maslowski for help with birds.

I'd also like to express my appreciation to the staff at North Light Books for all their support on this book and the three I've written previously. Thanks for helping me make a living doing what I like best! Thanks to Erika O'Connell for being my editor on this book, and to Kathy Kipp for jumping in to help on the homeward stretch.

METRIC CONVERSION CHART

TO CONVERT	TO	MULTIPLY BY
Inches	Centimeters	2.54
Centimeters	Inches	0.4
Feet	Centimeters	30.5
Centimeters	Feet	0.03
Yards	Meters	0.9
Meters	Yards	1.1

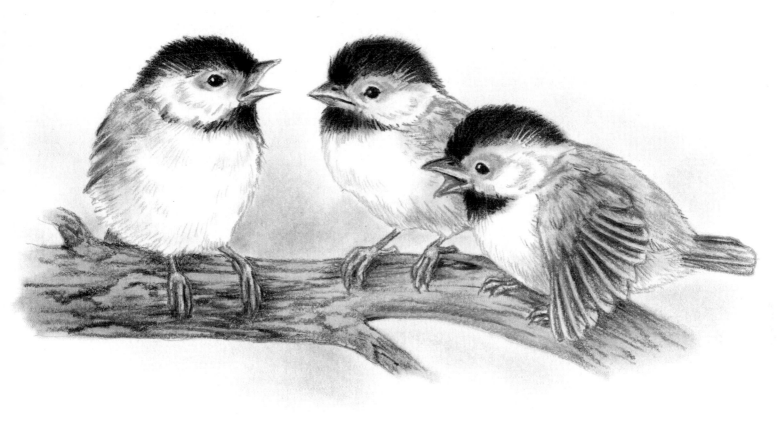

This book, as always, is dedicated to my dear
husband John, to my children Ian and Margaret,
and to my mother Jean McCoy, with love and
thanks. I would also like to dedicate it to the
Thompsons, with many fond memories.

table of contents

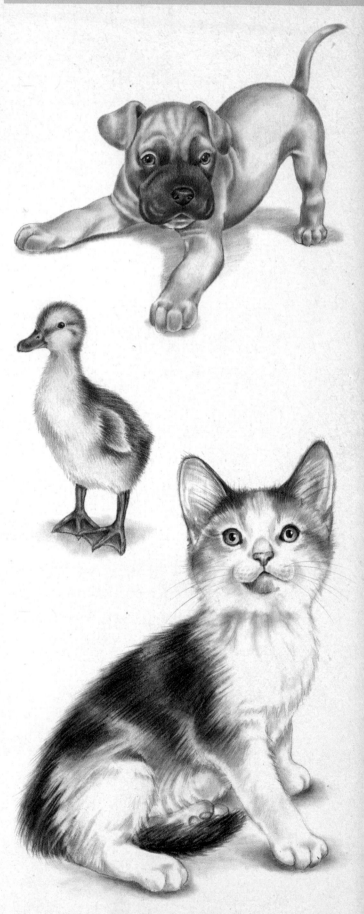

Baby animals have a universal appeal to people of all ages. Who can resist their large, captivating eyes and fragile, wobbly legs? If the animal you wish to draw is a new pet, then personal love and affection will add to your efforts to create a delightful drawing that is sure to put a smile on the face of anyone who views it.

In this book, I'd like to introduce you to some of my favorite techniques and tools. Remember, art is a learning process. I have been a professional artist since my teens, and I still learn something new with every piece I create! So try not to let insecurity about your abilities discourage you from drawing. The most important thing I have learned is that if you feel relaxed and joyful when you draw, it will show in the finished artwork and make it more appealing (even if the drawing isn't "perfect").

Keep a sketchbook and camera handy. You never know when the perfect moment will occur, and the more you practice with these tools, the more accomplished you will become. I hope you have as much fun using this book as I did writing it!

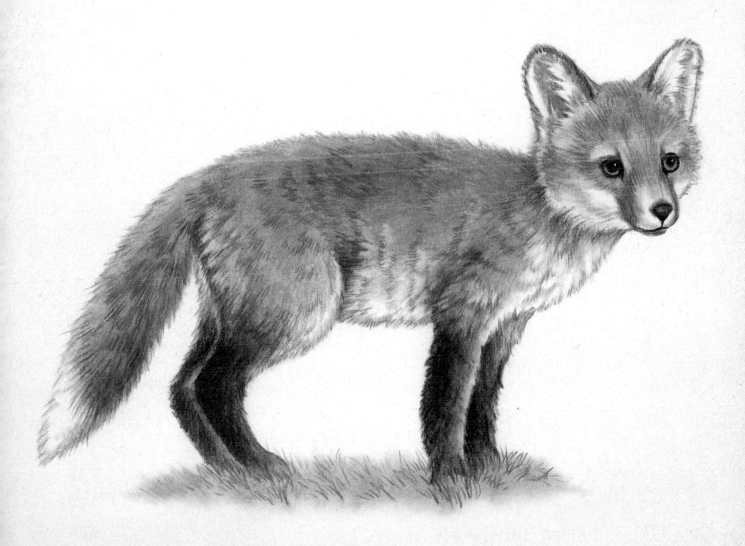

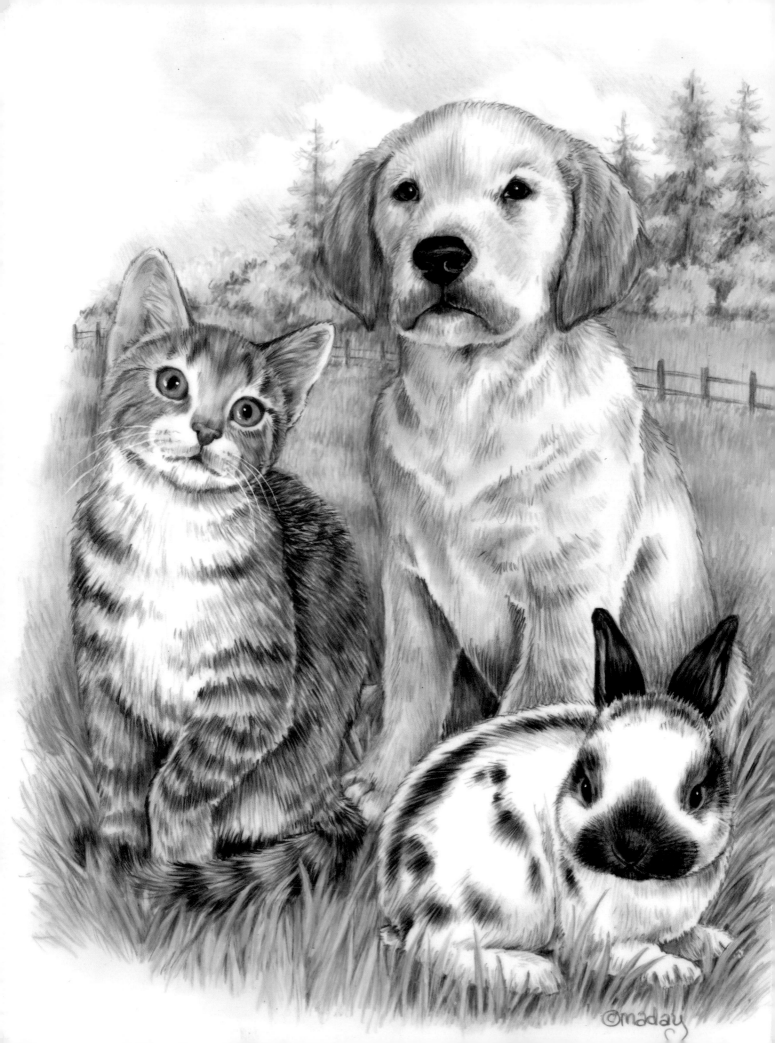

Materials & Techniques

One of the benefits of drawing is that you can create a lovely piece of art with minimal expense. However, you should still buy the best quality materials you can, as it is frustrating to battle with inferior supplies as well as your inexperience if you are a beginner. As you work your way through this book, I hope you will soon see an increase in both your skill and your confidence. There's no substitute for practice.

For the drawing at left, I began with various green and blue pastel pencils for the first layers of color in the background sky and grass. For large areas like this, try applying the colors with sponge makeup applicators, as they have a large blending surface. There is no extra pastel dust to smudge because it all gets worked into the surface of the paper, but it is still a good idea to keep a piece of tracing paper under your hand to avoid smears. Craft shops also sell sponge chalk applicators which are often used by card makers and other hobbyists.

I used a raw sienna pastel pencil for the first layers of color on the puppy, dark brown for the kitten, and patches of dark brown for the bunny. The clouds were lifted out of the blue sky with an eraser. For details such as the trees, shrubs, fence and grass blades, I used various dark and light green and brown colored pencils. Various browns were used for the details on the animals. (Techniques for drawing fur are shown step-by-step in each chapter in this book.) The eye highlights and kitten whiskers were scratched out with a craft knife.

Try reproducing this drawing with your own favorite pets. Photocopy a photograph of each animal, cut it out, and move the images around until you are satisfied with their placement. Then tape the cut photocopies together and photocopy them again. Now you have a composite reference photo to use for your drawing.

basic supplies

The materials listed here are my favorites. Feel free to experiment and substitute different products if you prefer.

Paper

For the drawings in this book, I used Strathmore 300 Series Bristol Board. The smooth finish is good for blending pencil drawings. The vellum surface has slightly more texture, which I like for charcoal and color drawings. If you wish to buy only one pad, buy the vellum finish, as I think it is more versatile.

I use 100-lb. (210-gsm) paper. The weight refers to how much a ream of that paper weighs. Heavier-weight paper is thicker. You don't need to buy a heavier paper unless you are going to paint on it.

Pencils

I like graphite pencils made by Derwent. The pencils I use most often are 2B. I also like 4H for tighter detail, and 4B for extra darkness. The letters on a pencil indicate whether it is hard or soft: B pencils are softer; H pencils are harder. The number refers to the level of hardness or softness. For example, a 4B pencil is softer than a 2B pencil. I also use Derwent charcoal pencils when I want a looser, smudgier effect.

Colored Pencils

My favorite colored pencils are Derwent's Studio Colour Pencils. Studio pencils are fairly hard and are good for detail work, although they can be blended if you don't press too hard when drawing with them.

Pastel Pencils

Pastel pencils are easier to control than pastel sticks, although sticks are better for coloring large areas such as backgrounds and the first layer of colors on an animal. Derwent Pastel pencils are excellent for very soft effects—essential when drawing baby animals.

I do lots of blending with cotton swabs and tortillions when using pastel pencils, and add details with colored pencils. Be careful when sharpening pastel pencils, as they break easily. Also try not to drop them, as the pastel can break inside the wood of the pencil, making them difficult to sharpen.

Blending Tools

There are several tools that are useful for blending. A tortillion is basically a piece of paper that has been twisted into a point on both ends. Buy several sizes and save them when they get dirty; a tortillion with a buildup of graphite is very useful for adding hints of tone to white areas.

You probably already have cotton swabs. I sometimes buy the ones with long wooden handles from medical supply shops, as they are easier to maneuver.

Fantastix by Tsukineko are shaped like a plastic pencil with a soft, spongy end. They come in "bullet point" and "brush point" and are available online. I like the bullet point.

Pencil Sharpeners

Choosing between an electric and a handheld sharpener is a matter of personal preference. I like the ease and speed of an electric sharpener; however, to get an especially sharp point, I rely on a handheld sharpener. Buy a good-quality metal one with a steel blade. If possible, get one with replaceable blades, as pastel pencils can dull a sharpener blade fairly quickly.

You'll know when you need a fresh blade by looking at the wood of the pencil: If it comes out of the sharpener looking smooth, your blade is sharp; if it comes out looking fuzzy, you need a new blade.

Erasers

Keep several types of erasers on hand. A kneaded eraser is made from soft putty. You can mold it into a point with your fingers and lift out highlights with the point. When it gets dirty, you can knead it until it is clean again. I also like eraser pencils for erasing fine lines and details. Click erasers are plastic tubes with a white stick eraser inside; you use them like a mechanical pencil. You may also want a large pink or white eraser for larger areas.

Drafting Brushes

These large brushes are useful for brushing away eraser crumbs. If you use your hand to brush them off the drawing, you will end up with a smudged drawing and a dirty hand.

Tracing & Transfer Papers

Professional illustrators perfect their sketches on tracing paper before doing the final drawing. If you start out by drawing on your bristol board, you'll probably end up doing lots of erasing and "do-overs," which can damage the surface of the paper. Have you ever tried to draw over an erased line? Chances are you ended up with a white, indented mark from the original line, no matter how hard you tried to erase it.

Do your sketch and make all your corrections on tracing paper, then use transfer paper and a sharp pencil to transfer the sketch to the bristol board. Transfer paper is a thin sheet that has been coated with graphite on one side. Tracing paper is also useful for placing under your hand when drawing: this will help prevent smudges on finished areas of the picture.

Acetate

Acetate is useful for making grids to place over your reference photos (see page 16). It comes in sheets or rolls, or you can purchase clear plastic report covers from an office supply store.

White Watercolor Paint

When adding highlights to an eye, I sometimes use a dot of Titanium White watercolor paint instead of lifting out the highlight with an eraser. This is especially effective if you want a bright, clear highlight. I prefer the more opaque Titanium White instead of Zinc White, which is more transparent. Use a small round paintbrush with a very fine point; you want a sharp dot, not a blurred one.

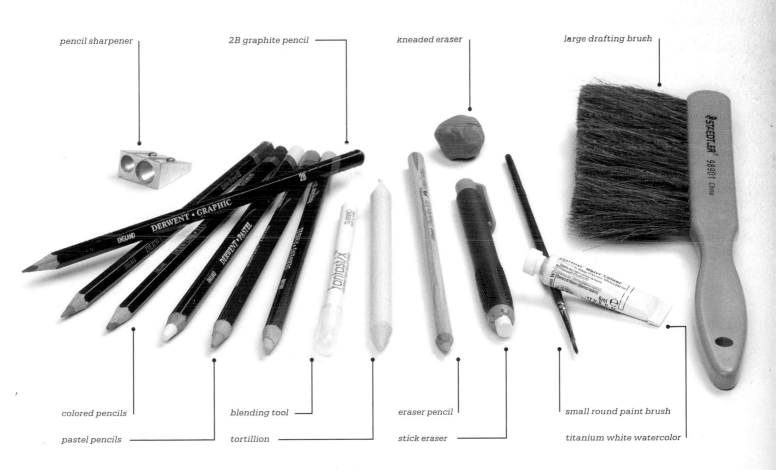

pencil sharpener　　*2B graphite pencil*　　*kneaded eraser*　　*large drafting brush*

colored pencils　　*blending tool*　　*eraser pencil*　　*small round paint brush*

pastel pencils　　*tortillion*　　*stick eraser*　　*titanium white watercolor*

9

blending & shading in black & white

Most of the drawings in this book require blending and shading. Shading is how you give an object form to make it look three-dimensional. The key to good blending and shading is to build up the tones gradually. If you press too hard with your pencil, you will create lines that are too heavy to blend.

Try not to scribble with your pencil. Gently rub the pencil on the paper, gradually letting it get darker and darker. Use less pressure for lighter tones. When finished, rub with a tortillion to blend, making sure to rub in the same direction as your pencil marks.

Pencil Position

Sometimes you will want to vary the marks you make by changing the position of your pencil. Holding the pencil on its side creates softer lines, which are good for shading large areas. Using the sharp point and holding the pencil as if you were writing is good for hard lines and details.

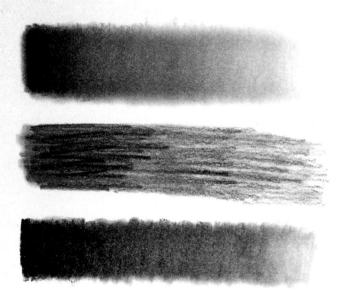

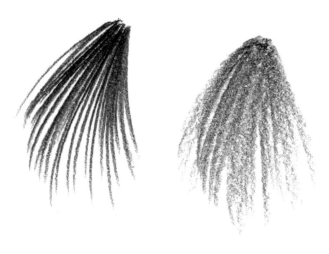

Blending Strokes

The top example shows a soft, gradual transition from dark to light. The middle example shows poor blending, with uneven tones and scribbled lines that show through. The bottom example shows blending with pastel pencils.

Pencil Position

The example on the left shows the hard lines made with the point of a pencil; on the right you can see the softer effect of using the pencil on its side.

shading to add form

Shading is what turns a flat circle into a rounded sphere, as shown below. For your first attempt, work fairly small; you'll find it easier to control. If you want your baby animals to look solid and rounded, rather than like flat cut-outs, you will need to use shading to add form, depth and roundness to every part of the animal's face and body.

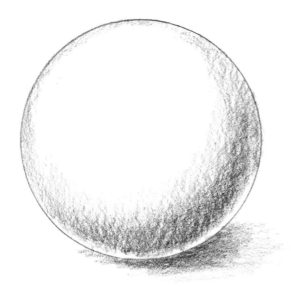

1 Use a template to draw a circle, or trace something like a small cup. Holding the pencil on its side, gently fill in shading with smooth strokes. Add a cast shadow under the sphere. Here the light is coming from the left so the shadow should go to the right. Leave a small strip of reflected light at the bottom of the sphere.

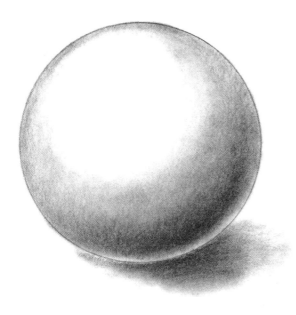

2 Use a tortillion to blend the shading. Move the tortillion in curved strokes to mimic the pencil strokes. If you lose the strip of reflected light at the bottom, go back and lift it out with a kneaded eraser formed into a point.

using colored pencils & pastel pencils

Colored pencils are a great way to create an image in color, as they are less intimidating than paint to many people. However, there are still some important techniques to learn if you want to do more than just fill in a coloring book!

One thing I really like about colored pencils is the way depth is achieved by layering one color on top of another. You can also create a feeling of richer colors by working on a tinted surface such as mat board.

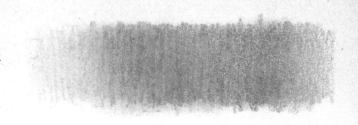

Blending Colored Pencils
Blending is achieved by rubbing the colors with a tortillion or other blending tool, just as you would for a graphite pencil drawing.

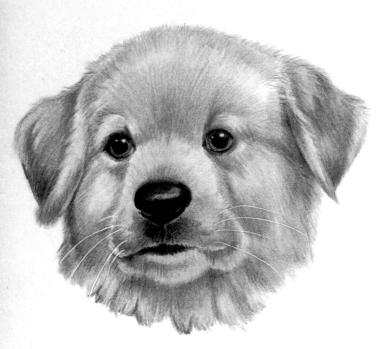

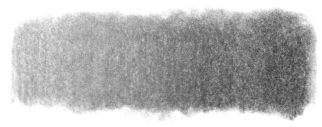

Burnishing
Burnishing refers to blending colors by rubbing across them with a white colored pencil. You can then add more layers over the top if desired. This technique tends to lighten the colors somewhat, so it works well for highlighted areas.

Impressing
Impressing is a great way to create white lines, such as for whiskers, if you are working on white paper. Using a sharp tool, such as a stylus or a pen that has run out of ink (be absolutely sure it's dry!), draw the lines you want to remain white, pressing hard so that the line makes a dent in the paper. When you color over it, the pigment won't go into the dent, so the line will remain white.

You can also scratch out white lines with a craft knife after the colored drawing is finished. This golden retriever puppy was drawn with pastel and colored pencils after I impressed the whisker lines.

Blending Pastel Pencils
Pastel pencils are best blended with a tortillion or cotton swab.

using cotton swabs

Occasionally I like to add some soft pastel pigment to my drawings using a cotton swab like a paintbrush. It creates a softer look when adding a little warmth to the inside of an ear or to a little pink belly.

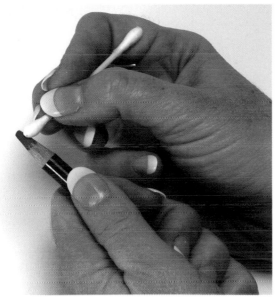

1 Rub a cotton swab over the tip of the pastel pencil to pick up the pigment.

2 Rub the pigment from the tip of the swab onto your drawing. This creates a softer smudge of color as compared to using pencil directly.

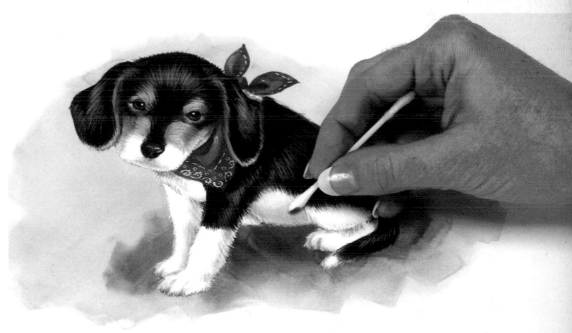

taking good reference photos

The challenge of drawing from life is that baby animals don't often stay still unless they are asleep. I like to do quick gesture drawings in my sketchbook, because that helps me understand the way the animal moves, but for finished drawings I rely on photographs.

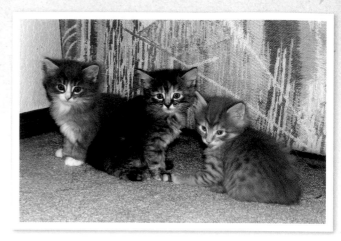

USE PHOTOCOPIES TO SEE VALUES

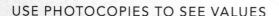

If you have a hard time seeing the variations in tone and values in a color photograph, try photocopying it to create a black-and-white reference. The values of light, medium and dark will become readily apparent because you won't be distracted by color.

Kittens

Keep your ears open for any friends who end up with a litter of kittens. They grow up really quickly, so don't waste time getting the photographs. Make sure you spend time getting to know the mother cat first, though, because you don't want to distress her with a lot of unfamiliar activity around her babies.

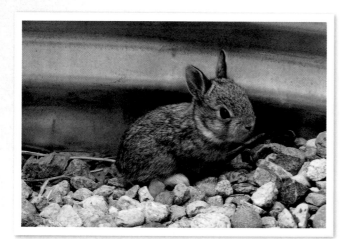

Bunnies

Some baby bunnies fell into our window well, and I took advantage of the moment while my husband was looking for a box to scoop them into so we could release them.

In a case like this, where the feet are hidden by the stones, I would use other references to help me draw the feet. Keep a file of magazine clippings and other reference materials, but don't copy anyone else's photos without permission if you plan to sell or print your work.

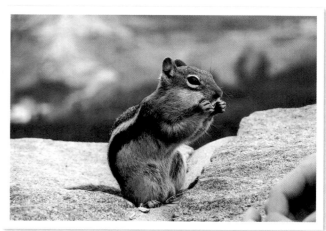

Wild Animals

Parks are a good place to get photos of wild animals like squirrels, deer, chipmunks, etc. Animals in parks tend to be somewhat accustomed to human company, so they are less likely to be frightened. Still, it's a good idea to have a zoom or telephoto lens so you can avoid getting too close for their comfort.

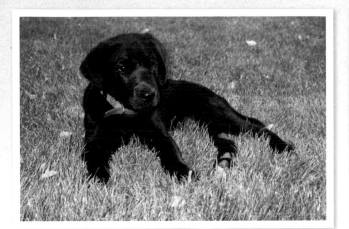

Puppies

When photographing pets, I try to avoid placing them on grass. This photo shows why: a lot of the legs and feet are hidden by the grass. If I wanted to draw this puppy in another setting, the lack of detail there could be a problem. Also, you might want to print a photo of a black-furred puppy lighter than usual to bring out some of the details in the darkest areas.

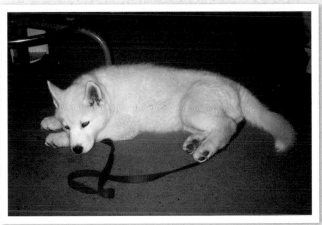

Sleeping Animals

This is a nice photo with a simple background. However, it doesn't engage the viewer because there is no eye contact with the subject. Sometimes a picture of a sleeping baby animal can be very sweet and touching, but in general I like the subjects to be alert and interacting with each other or with the viewer.

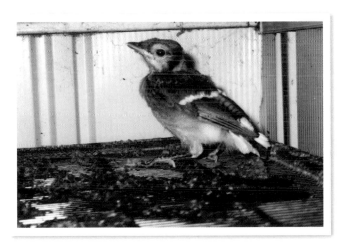

Birds

I find that baby birds are the hardest subjects to photograph, simply because you don't see them up close very often. This baby blue jay fell out of its nest and ended up in our shed. The photo has a busier background than I would like, especially around the feet, but sometimes you don't have any choice.

PHOTOGRAPHY TIPS

YOU DON'T HAVE TO BE AN EXPERT PHOTOGRAPHER TO TAKE ADEQUATE REFERENCE PHOTOS. JUST KEEP A FEW THINGS IN MIND:

- Keep a camera handy at all times, because photo opportunities happen when you least expect them.

- You'll need to take many photos to get a really good one (a digital camera is nice to have because you avoid wasting film).

- Have the animal fill as much of the frame as possible; it's impossible to draw from a photo where the subject is a little speck in the distance. Use a zoom or telephoto lens; if you get too close to the subject, the image will be distorted.

- Use natural light whenever possible. Flashes create flat, unnatural shadows and carry the risk of "red-eye." Overcast days are good; strong sunlight can create shadows that are too harsh.

- Finally, choose a background that is as simple as possible so it doesn't interfere with the subject.

using a grid

The grid method is a good way to create a drawing from a reference photo. It's easy to get overwhelmed by trying to copy the whole thing at once, but breaking it up into small pieces helps make the job less intimidating. Because you are concentrating on one small square at a time, it's easier to focus on the isolated shapes and lines that make up the picture as a whole.

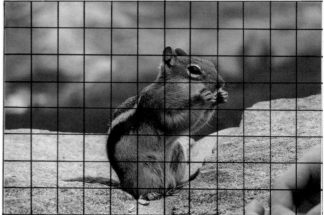

1 Create your grid with a fine-point permanent marker on a piece of acetate or a clear plastic report cover. This grid is composed of half-inch (13mm) squares, which is a good size if you are working with an ordinary 4×6-inch (10mm × 15mm) photo. If you are using a larger photo, such as an 8×10-inch (20cm × 25cm), increase the grid squares to one inch (25mm).

2 Lay the grid over your photo and copy the lines in pencil onto tracing paper. (If you are working from a black-and-white photocopy, make an extra copy and draw the grid directly on the paper, or photocopy the image with the acetate grid in place.)

Focusing on one square at a time, trace the outline of what you see in each square. Gradually you will end up with a line drawing of your photo.

3 When your grid drawing is complete, use transfer paper under the tracing paper to transfer the line sketch to your final drawing surface. Do not transfer the grid lines. When you are finished with your drawing, save the grid so you can reuse it.

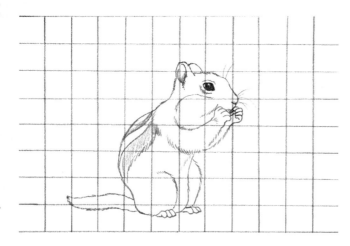

REVERSE IT

To check the accuracy of your drawing, sometimes it helps to hold it up to a mirror. By looking at the image in reverse, you can see what is actually there, rather than what your brain wants to see. Any flaws in proportion or perspective should be revealed.

transferring a tracing-paper sketch

Transfer paper is handy for transferring your tracing paper sketch to your drawing paper. Transfer paper comes in several colors, but I generally use plain graphite. Saral is my favorite brand, but there are many other good brands. Choose a paper that is wax free. You'll find transfer papers at any art or craft supply store. They come on a roll or in packets of indivdual sheets, and can be used over and over until you no longer get good lines.

DRAWING VERSUS TRACING

You may wonder why I don't suggest just tracing the photo, since you are working with tracing paper. Although it's something many professional artists do, especially if they are in a hurry, you won't learn anything about the art of drawing if you do this. If you rely on shortcuts like tracing the photo, you will become dependent on them, and could lose whatever drawing skills you already have! Once you become more experienced, you may find that you can draw what you see directly, and can skip the grid method altogether.

Using Transfer Paper

Attach your tracing-paper sketch to your final drawing surface with drafting tape to keep it from shifting around. Put a piece of transfer paper between the tracing paper and your drawing surface. Use a pencil with a hard, sharp lead (or a stylus) to transfer the sketch. Do not press too hard, or your transferred lines will be too dark and you could impress the lines into the drawing surface. You need only the bare minimum of your sketched lines to appear. Lift up one corner of the transfer paper to check your lines but be careful not to let the tracing paper shift out of position.

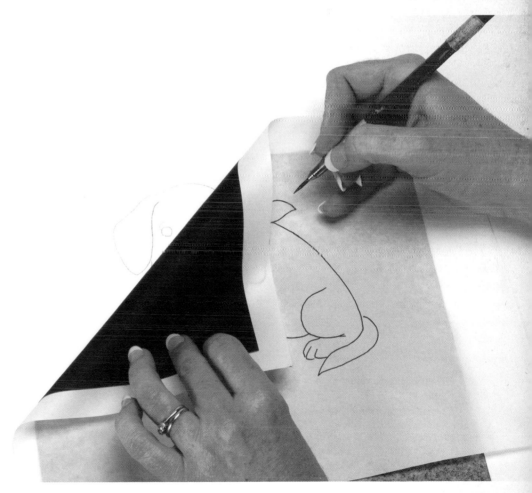

sketching basic animal shapes

Part of learning how to sketch an animal freehand, rather than using a grid, is learning to see the basic shapes that make up the animal's form. Ovals and egg shapes are very common, but you will also use circles, cones, cylinders and triangles. Adding curved guidelines to the head will help you place the features. Practice with the sketches on this page.

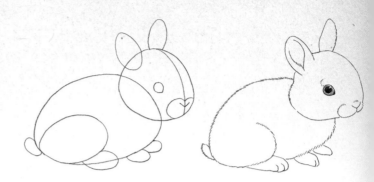

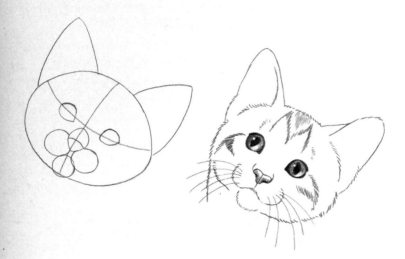

Baby Bunny

The drawing above shows how a baby bunny is composed of egg shapes and ovals. The curved line down the face will help you in placing the features. Using tracing paper, build upon the basic forms to add details.

Kitten Face

When drawing a face, it is very easy to get the features out of place, especially the eyes. Drawing curved guidelines helps make sure the eyes and nose are placed evenly. The eyes are slanted, so only the outer corners rest on the curved line. This kitten's head is based on ovals and triangles. The triangles for the ears have curved lines; there are no straight lines on an animal.

Foal

I find horses and foals (baby horses) somewhat difficult to draw. The basic shapes of a foal are primarily based on cylinders. Pay particular attention to the placement of the joints in the legs. If necessary, measure the length of each leg segment with a ruler. Notice that the back legs have different measurements than the front legs.

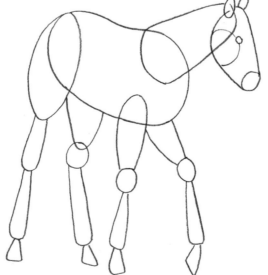

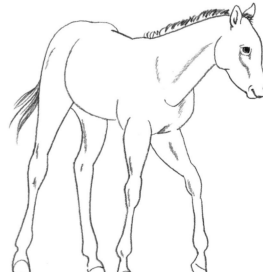

Getting the Proportions Right

It is always a challenge to get correct proportions, whether you are drawing animals or people. The relationship of the head to the body is important, and it's easy to get it wrong.

One way to achieve correct proportions is to measure by "heads." Measure the size of the head and use that measurement to compare the size of the rest of the body. For example, the average adult human is eight heads tall.

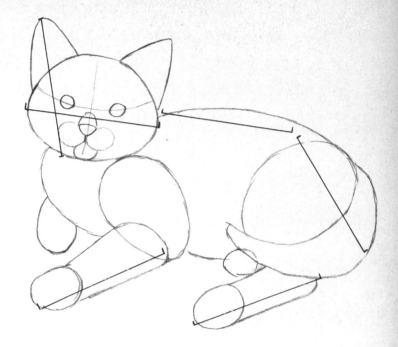

Kitten Proportions

This shape sketch of a kitten (above) shows how the proportions of the head compare to the rest of the body. For example, the distance from the tip of the ear to the bottom of the head is exactly the same as the width of the head from side to side. It is also the same distance from the elbow joint to the tips of the toes. The main part of the body is two heads long.

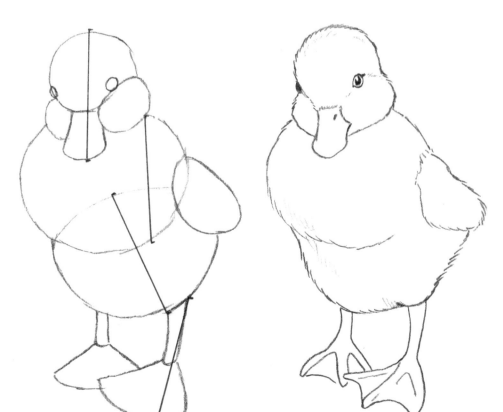

Duckling Proportions

In this drawing of a duckling (at left), the measurement of the head is the same as the length of each segment of the body, as well as the length of the leg. The wing is half a "head" long.

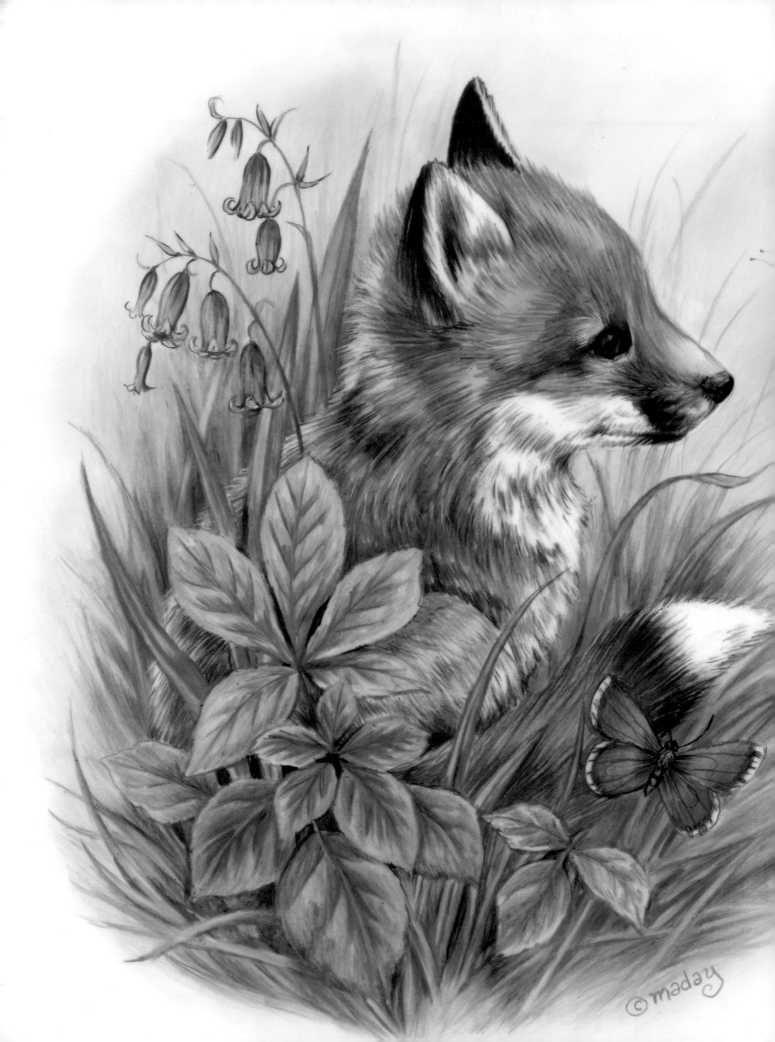

Bits & Pieces

In this chapter, we will study in detail the fur and feathers, body parts and facial features that are characteristic of each animal in this book. For an animal drawing to be successful, it should create an emotional response in the viewer. (When I was a greeting card artist, we called that the "aww" factor.) Getting the facial features right, especially the eyes, is the key. Fur texture is also important, especially for cuddly baby animals. You know you've done a good job when the viewer wants to reach out and touch the animal.

On the drawing of a fox kit at left, I used green pastels with a touch of blue for the first layer of colors in the background, and burnt sienna pastel for the first layer of color on the fox. For large areas like these, use a stick of chalk pastel rather than a pastel pencil, and rub your applicating tool across the surface to pick up pigment, just as you would a pastel pencil (see the instructions on page 13).

Next, I added details. I used dark brown and black colored pencils for the fox, and scratched out some white details like the eye highlights and a few hairs with a craft knife. (Note how the placement of the eye highlights shows that the fox's eyes are gazing intently on the butterfly.) For the grass and foliage details, I used colored pencils in various dark greens, yellow ochre, and burnt sienna. I used blue colored pencil for the flowers and butterflies, ultramarine for the dark blues, and added more details to the butterflies with dark brown and black. There are also slight touches of lavender in the blue areas for liveliness and depth of color. The most delicate details, like whiskers and antennae, were done with a sharp 4H pencil.

basic fur strokes

There are a couple of things to remember when drawing fur. First, your lines should be smooth and tapered, not hard and firm. Also, your lines should follow the direction of hair growth on the animal.

To create fur strokes, begin where the hair connects to the animal's body (the hair root). Gently increase the pressure through the middle of your pencil stroke, then gradually lift the pressure so the line tapers. Remember, the fur conforms to the shape of the animal.

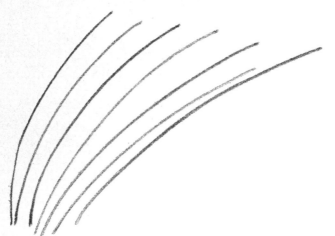

Incorrect Fur Strokes
These pencil strokes are too harsh. The pressure is even and too hard throughout, and the strokes do not taper.

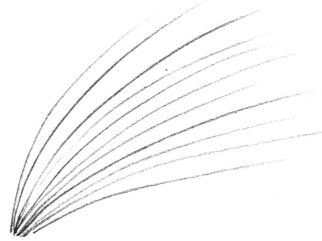

Correct Fur Strokes
These strokes are correctly tapered. Remember that the lines should never be straight.

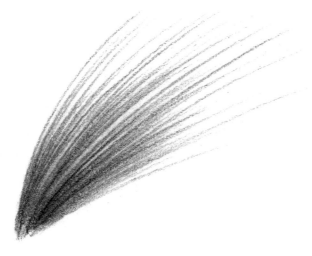

Dense Fur
Here I have added more pencil strokes to make the fur more dense, and I have blended the strokes with a tortillion.

If you're a beginner, you may find it useful to create a "fur map" to help you visualize the direction of hair growth before you begin your animal drawing.

1. Lay a sheet of acetate or tracing paper over your photo.

2. Draw an outline of the animal on the acetate or tracing paper.

3. Study the photo carefully. Imagine you are stroking the animal or brushing its fur. Your hand would follow the direction of hair growth, or the animal would be uncomfortable.

4. Draw arrows on the tracing to indicate the direction your pencil strokes should follow. (You don't need to draw the arrows on your final drawing; just use the fur map as a guide.)

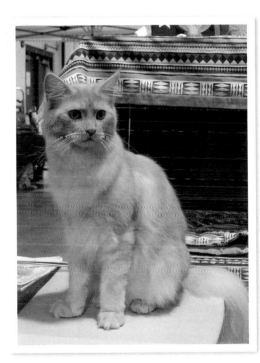

Reference Photo
I sometimes attend dog and cat shows to take reference photos. That way I know I'm getting photos of prime examples of the breeds. This photo was taken in the grooming area at a local cat show.

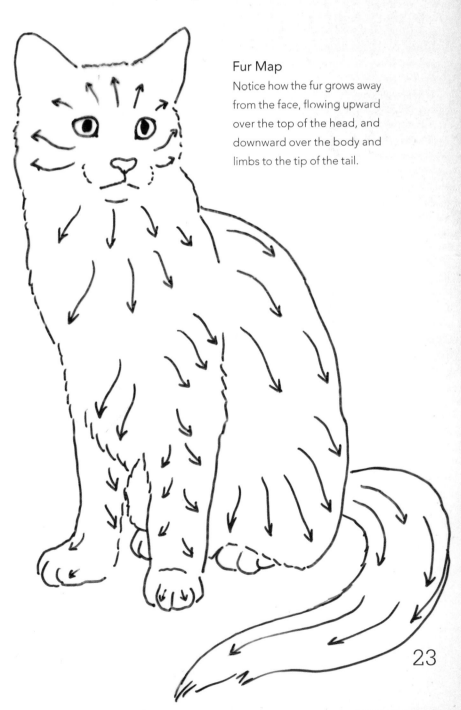

Fur Map
Notice how the fur grows away from the face, flowing upward over the top of the head, and downward over the body and limbs to the tip of the tail.

different types of fur

Some animals have short, dense coats, and others have long, flowing fur. Some fur is coarse and wiry, while another animal might have smooth, silky hair. And let's not forget baby birds with their soft, fluffy down.

The examples on this page show the differences between various types of fur. They were drawn on vellum finish bristol board using 4H and 2B pencils. Remember that your fur strokes should taper at the ends.

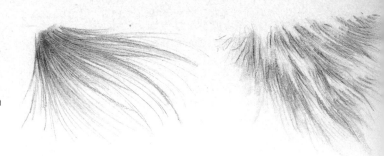

Long, Flowing Fur
Use smooth, sweeping strokes. Fur usually grows in layers, so there may be shorter, denser fur under the longer hairs. Use more pressure on the pencil for the darker strokes.

Soft, Fluffy Fur
Draw shorter, varying strokes, and blend with a tortillion. Use the buildup of graphite on the tortillion to draw soft fur strokes at the edges.

Short, Smooth Fur
Use short, delicate strokes that are close together. Short fur reveals the form and musculature beneath, so there should be highlights and shadows within the fur to show the form below. Blend slightly with a tortillion.

Overlapping Feathers
Feathers overlap in rows with each one offset from the one below it. Your parallel pencil strokes should radiate outward from the central vein of each feather. There is a lighter edge on each feather that helps separate it from the ones below.

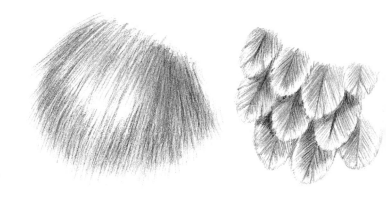

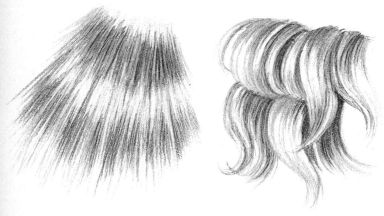

Striped Fur
Use firmer pressure for the darker hairs. Additional lighter hairs can be picked out by cutting the end of a click eraser and using the sharp edge to "draw" them.

Curly Fur
Draw locks of fur rather than individual hairs. The curls should overlap in layers, and should vary in size for a natural look.

24

Just as fur follows the shape of an animal's body, feathers conform to the shape of the bird. The majority of feathers are "contour feathers." Underneath the contour feathers on many birds are "down" feathers. These vary according to species, and do not have the central rachis that a contour feather has. Down on a baby bird is called "juvenile down."

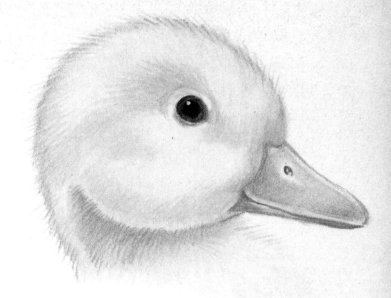

Contour Feather

vane

rachis

quill

Duckling

I used Derwent pastel pencils for the down feathers, and Studio pencils for the beak, eye and details. When drawing something that is extremely soft, such as down, pastel pencils are very effective; you can blend them until they are very blurred and soft. For downy baby birds, you want very few hard lines in the feathers.

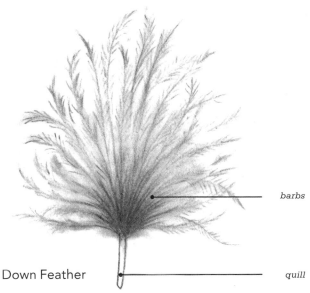

barbs

Down Feather

quill

eyes

Getting the eyes right is essential to creating a success-ful animal drawing. Animals have very expressive eyes, and this is one of their main methods of communicating their feelings to us.

Baby animals typically have very large eyes. This is because the eyes reach their full mature size when the animal is still quite young. Even in humans, the eyes reach full size by the age of three years. These large eyes help give baby creatures their appealing, defenseless look. I often start my animal drawings with the eyes, because I get more emotionally involved in my drawing when it is "looking back at me."

The shape of the eye and pupil varies among species. If you are having trouble creating eye contact or placing highlights, work it out on your tracing paper before try-ing it on your final drawing. Too much erasing can create a smudged appearance.

I also like to leave the white of the paper for the high-lights, drawing around them rather than erasing them out. If you do this, soften the edges of the highlights with an eraser pencil.

Make the Eyes Expressive
In this charcoal sketch of a kitten, the eyes are making contact with the viewer, which helps create an emotional attachment.

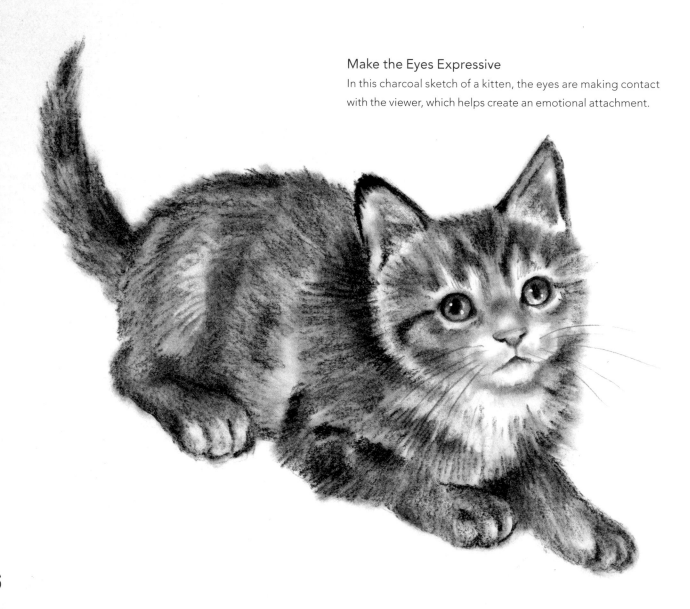

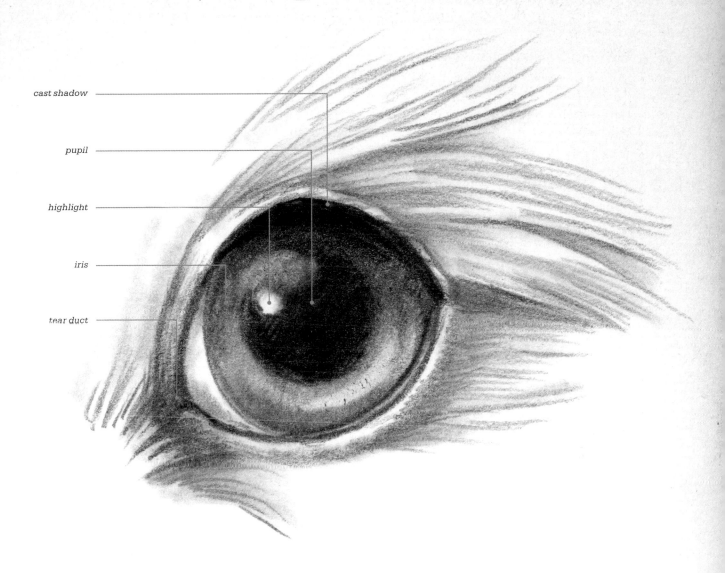

cast shadow

pupil

highlight

iris

tear duct

Parts of the Eye

The hairs start at the eye and grow outward. The hair growing up from the nose meets and overlaps the hair at the bottom of the eye. The upper lid casts a shadow over the iris.

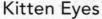

Puppy Eyes

Eye shape and color can vary among the different breeds of dogs, but most dog eyes have round pupils. Sometimes the eye can be so dark that it is hard to tell where the iris stops and the pupil begins.

Kitten Eyes

Cat eyes have vertical pupils. In bright light they are just thin slits, but in dim lighting they become almost round. Cat eyes vary slightly in shape between breeds. For example, a Siamese's eyes are more slanted and almond-shaped than a Persian's. As with any baby animal, kitten eyes appear larger in proportion to the face than they do in an adult cat.

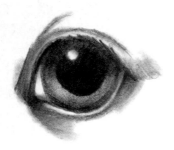

Beagle Eye

A beagle's eyes are large, round and dark. The drooping outer corners give the beagle his characteristic "sad-eyed" look.

Basset Hound Eye

Some dogs have a lot of heavy folds and wrinkles. This basset hound puppy has eyes that droop underneath, showing the inside of the lower eyelid, due to the heavy skin around the eye pulling it down.

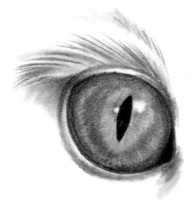

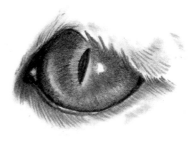

Kitten Eye

When drawing a kitten's eye, make your pencil lines radiate out from the pupil, then blend with a tortillion. Dark fur grows from the tear duct along the side of the nose.

Kitten Eye

This is a three-quarter view of a kitten's eye. Notice the dark rim and the shadow from the upper eyelid. Sometimes there is a highlight from moisture in the tear duct.

Piglet Eyes

The eyes of a piglet appear almost human, both in shape and anatomy. They have pronounced "whites," and the pupils are quite round.

Foal and Fawn Eyes

The eyes of horses and deer have horizontal pupils. In low light, they widen and become more round. The eyes are large and reflective, so sometimes the pupils don't show very much. Some horses actually have blue eyes. Horses and deer also have lovely long eyelashes.

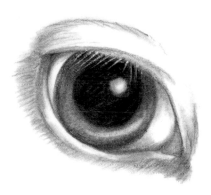

Piglet Eye

To draw the white eyelashes frequently seen on piglets, try scratching them out with the tip of a craft knife. This technique is called "sgraffito." There is often a pronounced hairless rim around the eye as well.

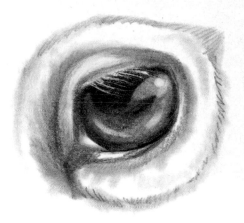

Fawn Eye

Drawing baby animals with dilated pupils gives them a vulnerable and appealing look. A fawn has horizontal pupils. The eyes look dewy and wet.

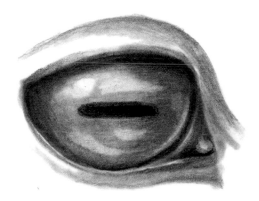

Foal Eye

I have left the eyelashes out of this drawing to make the eye more visible. If you wish to add them, try the sgraffito method.

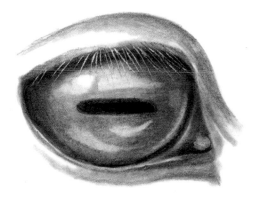

Foal Eyelashes

This drawing shows some eyelashes that have been scratched out. Do not scratch too much, or the surface of the paper will become rough.

29

drawing eyes

materials

SURFACE
bristol board (vellum)

PENCILS
DERWENT STUDIO COLOUR PENCILS:

Blue Grey

Brown Ochre

Chinese White

Copper Beech

Golden Brown

Ivory Black

May Green

Spectrum Blue

Terracotta

DERWENT PASTEL PENCILS:

Burnt Sienna

Chocolate

OTHER SUPPLIES
cotton swabs

tortillion

small round paintbrush

Titanium White
 watercolor paint

craft knife (optional)

Kittens are my favorite subject to draw, and the eyes are my favorite part. If you are in doubt about where to place the highlight, practice with a dot of white paint on an acetate overlay. The highlight frequently overlaps the edge of the pupil into the iris. Placement of the highlight can affect whether the animal appears to be looking at you or into the distance, so it is important. Not all kittens have as much color variation within their eyes, but I thought these would be fun to draw.

1 Begin by filling in the entire eye with a layer of Brown Ochre. Layer May Green over the center, and Spectrum Blue around that. Blend with a tortillion. Add an Ivory Black pupil. Looks a little creepy so far, doesn't it?

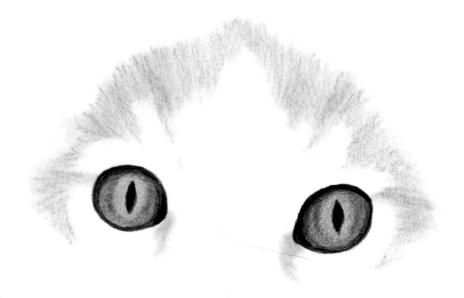

2 Outline the eyes with Copper Beech and Ivory Black. Add shading to the iris with Blue Grey. Lay in the fur with a Burnt Sienna pastel pencil and blend with a cotton swab.

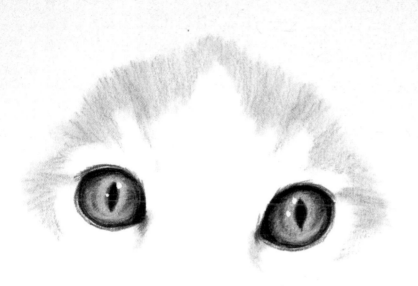

3 Continue shading the iris and burnish with Chinese White. Dot in highlights with Titanium White watercolor paint and a small round brush (or you can scratch them out if you prefer). Draw around the eyes with Terracotta, and add touches around the pupils.

4 Add very light shading to the fur with a Chocolate pastel pencil, then blend. Add delicate fur strokes with a Golden Brown Studio pencil. Add darker fur lines with Copper Beech, but be careful not to press very hard.

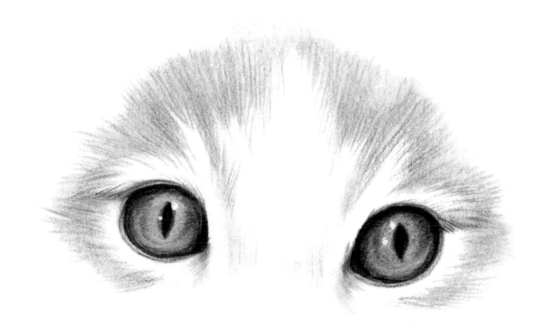

noses & mouths

Like people, animals are capable of having expressive mouths—especially puppies, who often seem to smile. Many animals have prominent whiskers. For white whiskers against dark fur, try adding them by impressing with a stylus before you begin your final drawing, by erasing with an eraser pencil, or by scratching out with a craft knife.

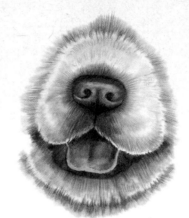

Open Puppy Mouth
This drawing of a golden retriever puppy shows how an open mouth and visible tongue give the effect of a happy expression.

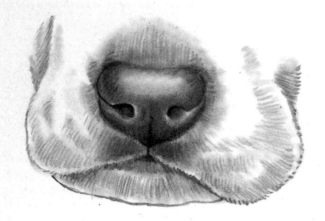

Closed Puppy Mouth
On the other hand, this Weimaraner puppy's closed mouth (left) and drooping lip give him a wistful, pensive expression. A dog's nostrils are almost comma shaped; this is called the "alar fold."

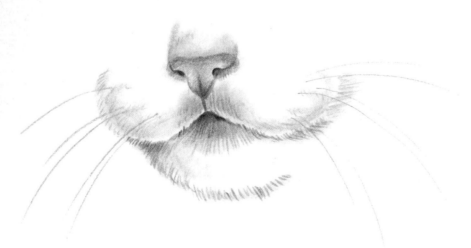

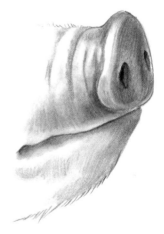

Kitten Muzzle
Puppies and kittens have a line down the center of their noses called a "septum." The line between the mouth and nose is called the "philtrum." When shading a very soft area such as this kitten's muzzle, I like to use just a dirty tortillion rather than a pencil to add any tone in that area.

Piglet Snout
Piglets have soft, flat snouts with rather round nostrils. They often appear shiny because their noses are moist, but they also have quite a few wrinkles, even in a very young piglet.

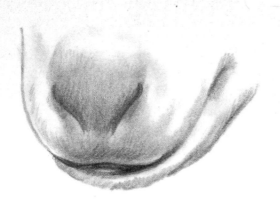

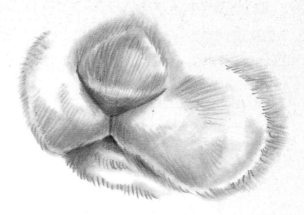

Lamb's Muzzle

Lambs have sweet faces, with mouths that appear to smile. Their nostrils are slanted slits. On a white lamb, a lot of the pink skin shows through around the nose and lips.

Bunny's Muzzle

Baby bunnies also have slanted nostrils. The fur grows away from the nostrils, up the nose, and down toward the mouth. Using blended pastels can add softness when working in color.

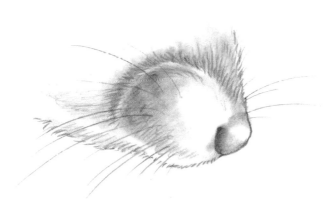

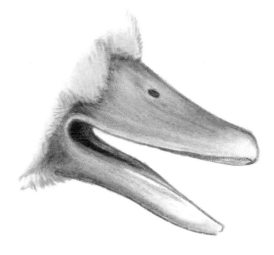

Mouse Muzzle

The mouth of a mouse is not always visible, as it is hidden by the rest of the muzzle and the position of the head. Mice have many fine whiskers. I find that using a very sharp, hard lead pencil, such as 4H, works well for these.

Duckling Beak

This duckling's beak shows again how an open mouth can convey a happy appearance. When drawing a surface such as a beak, burnishing with a white colored pencil can be useful for creating a smooth appearance.

33

ears

The position of an animal's ears can be a good indicator of its mood. For example, a kitten with ears that are twitched back is signaling irritation. With many animals, ears that are pricked forward are showing alertness. When horses are relaxed, their ears swivel outwards, and when they are feeling aggressive, they lay their ears right back. Rabbits will lay their ears back when they are trying to be inconspicuous.

Puppies seem to have the greatest variation in ears between the different breeds. There are cocker spaniels with long, flowing ears, German shepherds with upright ears, and Dobermans, whose ears have been docked to an upright, pricked position.

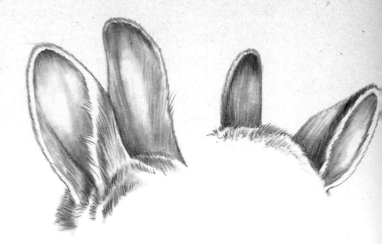

Bunny

A baby bunny's ears are very short in proportion to its head size, compared to the ears of an adult rabbit. This is important to note, as many people draw the ears on a baby bunny much too large, and that takes away from the infantile appearance. The adult ears are on the left in this drawing, and the baby bunny ears are on the right.

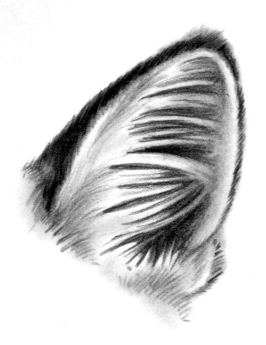

Puppy

This is a German shepherd puppy's ear in profile. The "ear pocket" is visible. This is the flap of skin on the outer edge of the ear that makes a small pocket. Your drawing will look more realistic if you include this (on animals where it occurs) than if you make the edge a smooth curve.

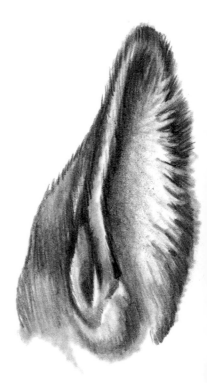

Fox

This is a front view of a fox kit's ear. The ear pocket is visible, although not as much as it would be in profile. To add tints of color to the white hairs, try rubbing a cotton swab across a pastel pencil and use the pigment you pick up to add a blush of color. For the white hairs, I drew the negative space around them, leaving the hairs as plain paper.

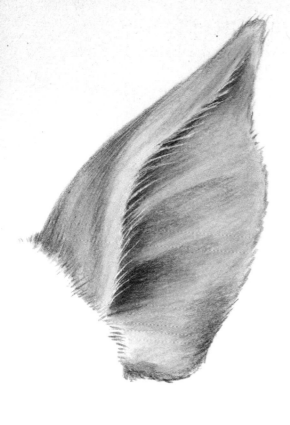

Piglet

Piglet ears are large and triangular. Sometimes they may be flopped over, but frequently they are upright. They have a velvety appearance. Burnishing with a white colored pencil can be helpful in achieving this. The delicate white hairs are scratched out with a craft knife.

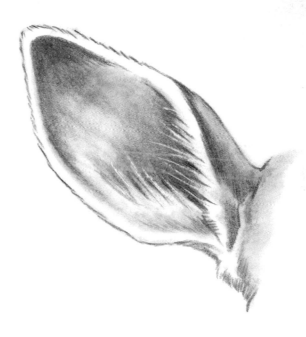

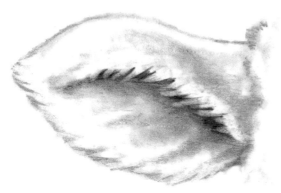

Lamb

Lamb ears are typically held out almost horizontally from the head. On white lambs, the skin shows through the white fleece on the ear. Blending with circular motions of a tortillion will help achieve a fleecy look.

Fawn

A fawn's ears are quite large in proportion to its head size. This is typical of many, although not all, baby creatures: the ears, as well as the eyes, appear larger than they do at the adult stage.

paws & hooves

Baby animals generally have small, delicate feet and legs that are shorter and thinner than their adult counterparts. Puppies, on the other hand, often have oversized paws, and the feet of baby birds can also seem large and clumsy.

Beginning artists may be tempted to hide the animal's feet in grass or hay, because feet can be the most intimidating body part to draw. However, if you have good reference material, and if you practice, you can end up with a drawing that is much more convincing because it includes the feet.

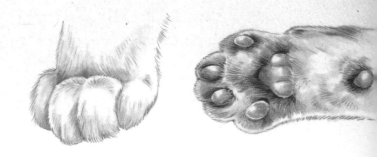

Kitten Paws
Kittens and cats have retractable claws. Often there is a small space in the fur of the toes where the claw has retracted. The front foot has a dew claw, which is above the other toes, as if it were a thumb; beyond that there is a pad called the carpal pad. The back feet do not have dew claws.

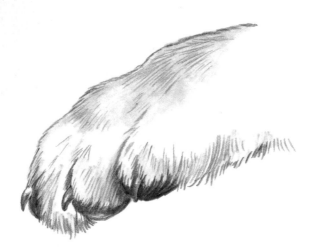

Puppy Paw
Puppies and dogs do not have retractable claws. They also have a dew claw and carpal pad on the front paws. In this side view, the dark paw pads are clearly visible. Puppy paw pads are relatively large, and not as soft as a kitten's. The hair grows quite thickly between the pads.

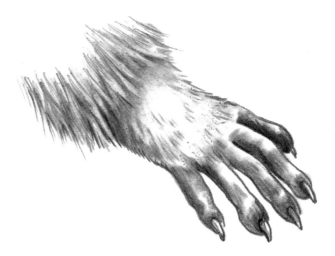

Fingerlike Paw
Raccoons and mice have paws that resemble hands. The long hair of the legs stops at the wrist. The paws are very mobile and can be used for manipulating objects and food much as a human's hands do. Seeing an animal in a humanlike pose can be very appealing to many people.

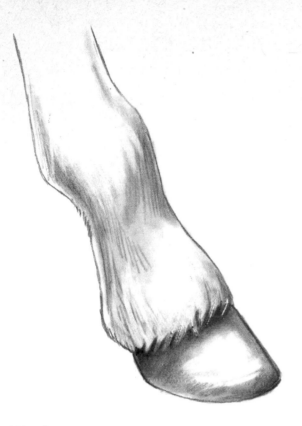

Foal Hoof

Many people find the legs and feet of a horse to be the most challenging part of the animal to draw. A foal's legs are thin and spindly, and the joints appear larger proportionally than they do on an adult horse, while the hooves are small and dainty. The hoof is angled, and the front is longer than the back.

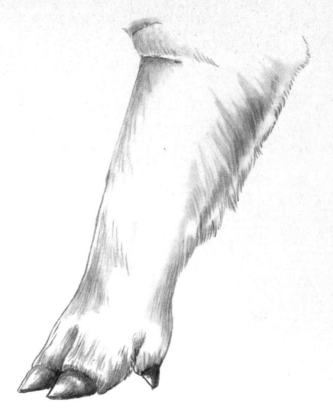

Piglet Hoof

Piglets have cloven hooves. In other words, the hoof is divided into two toes. They have large dew claws, one on each side of the foot. Their legs are short, stocky and firm.

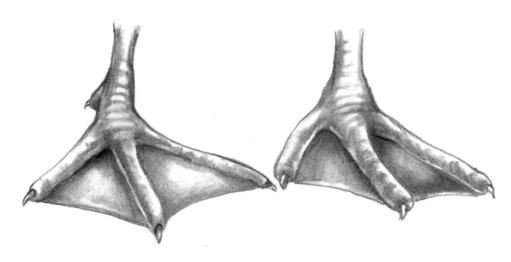

Webbed Feet

Ducklings and other water birds have webbed feet. There are three toes with very small claws at the end, with a small spur at the back. The spur does not always show in a frontal view. The feet have smooth scales and appear shiny. Wild ducklings typically have darker feet than domestic ones.

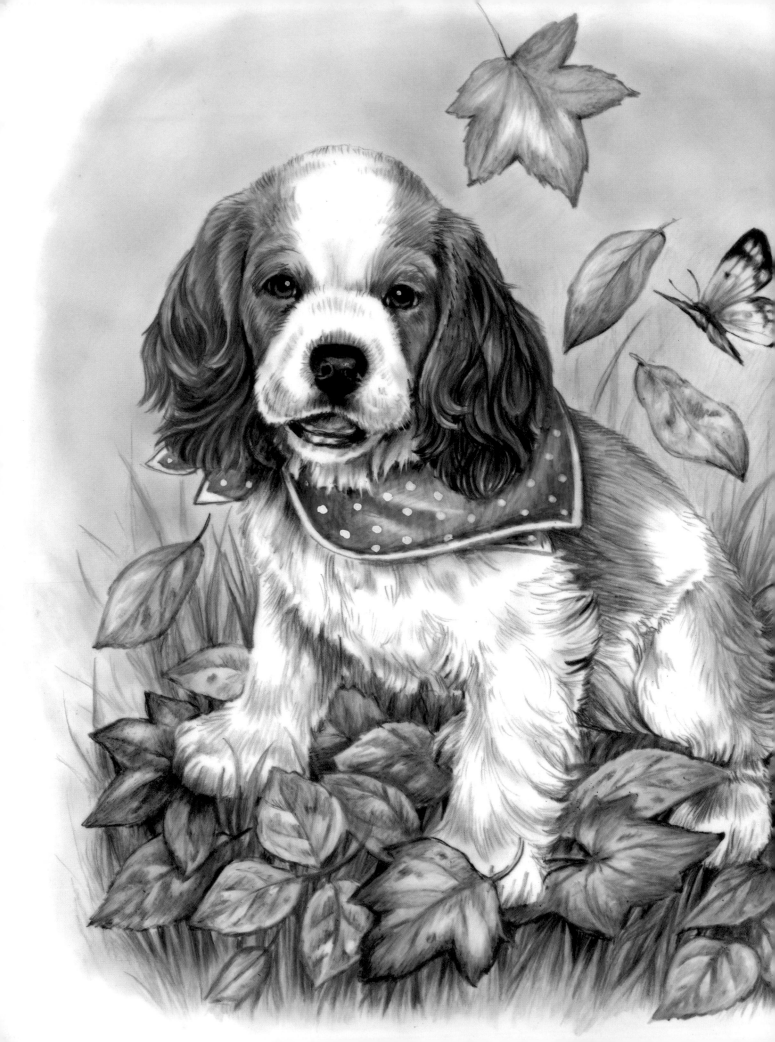

Puppies

In the animal kingdom, one of the species with the greatest variety of breeds is dogs. From the tiny Chihuahua to the massive Great Dane, there are dogs with long hair, short hair, stocky bodies, sleek bodies, long legs, short legs, and just about everything in between. In this chapter, I have tried to include puppies from as many breeds as possible, and I have even included a close relative: a wolf cub.

For the puppy drawing at left, I used a composite of several different photos. I thought the autumn-colored leaves would work well with the puppy's fur coloring. Adding a complementary color like the blue bandanna helps add interest and keeps the drawing from being too bland.

Once again, I began the first layers of color with pastels, using greens and blues for the background, and burnt sienna for the brown areas on the puppy. If any color overlaps areas where it shouldn't, erase it with a white eraser.

Next, I added details to the fur with dark brown and reddish brown colored pencils. Be careful—too much brown and the soft white fur will start to look dirty. The eyes and nose were colored with dark brown, and then black details were added. I colored the bandanna blue, and shaded it with dark gray. The spots were added with white watercolor paint and a small brush.

For the leaves and butterfly, I used a medium yellow colored pencil for the base color, then added details with dark brown, raw sienna, orange, light green, and dark red. The grass details were added with dark green and brown colored pencils.

keys to drawing puppies

The canine family has the most variation between breeds of any animal. Each breed has its special characteristics that set it apart, whether it is fur texture, ear or nose shape, or body size and shape. Here are some things to keep in mind when working on your puppy drawings.

Relative Puppy Sizes
This drawing illustrates the relative size differences between a chihuahua puppy, a golden retriever puppy, and a great dane puppy. Paw size is a good indicator of future body size. See how adorably big and clumsy-looking the great dane's feet are?

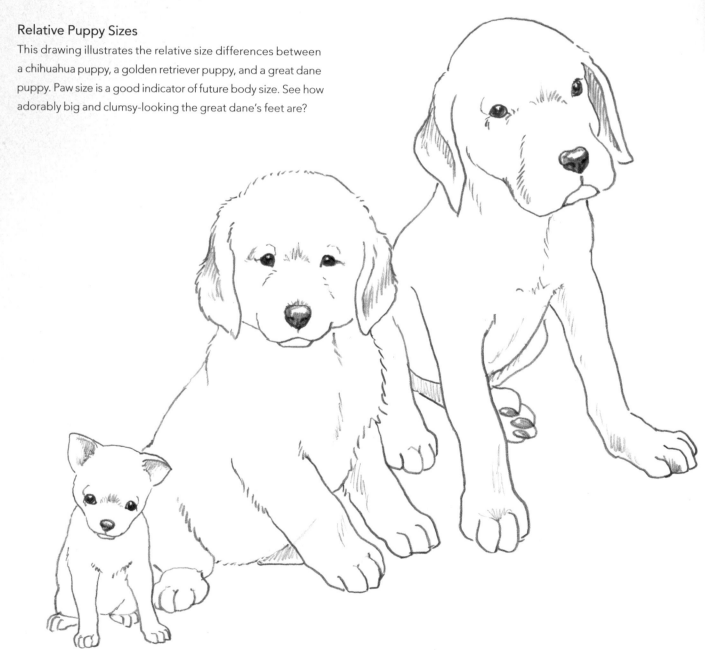

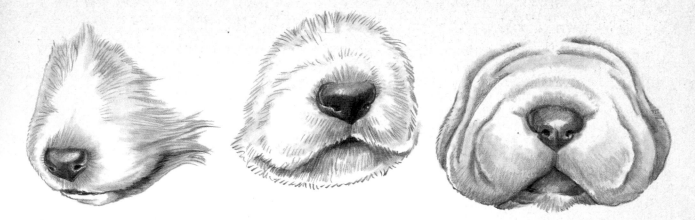

Noses

There is a great variety of muzzle shapes among puppies. For example, collies and greyhounds have long, slender muzzles, while bulldogs, pugs, and shar-peis have flat, "squashed" snouts with many wrinkles. In the illustration above, you can see (left to right) a Shetland sheepdog puppy, a golden retriever puppy, which has a square, boxy muzzle, and a shar-pei. Of course, these features are softer and less pronounced in a puppy than they are in an adult dog.

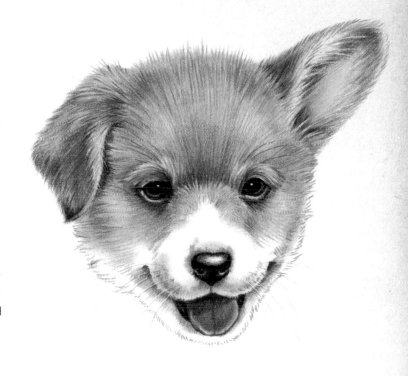

Ears

Some puppies have upright ears, and some have ears that flop over. This cute little fellow has one of each! Sometimes little oddities like this can add a lot of personality to your drawings. For this drawing, I impressed the whiskers first with a stylus, then touched them up with a 4H pencil when the drawing was finished.

Feet

On puppies with short hair, it is very easy to see the toes and claws on the feet, but long-haired puppies' feet can just look like little balls of fluff. Try to avoid drawing paws that are stretched out toward you, as this type of foreshortening is very difficult to achieve.

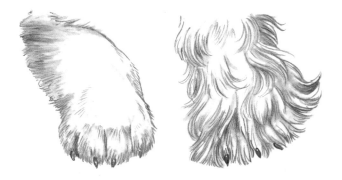

wolf cub

materials

SURFACE

Canson Mi-Teintes
paper (white)

PENCILS

GRAPHITE PENCILS:

2B

4H

CHARCOAL PENCIL:

medium

OTHER SUPPLIES

click eraser

craft knife

tortillions

tracing paper

transfer paper

Our domesticated dogs are descended from wolves. Wolves have upright ears and a firm, square nose. Adult wolves have a fur ruff around the face and slightly slanted eyes, but these features are softer and more rounded in juveniles. Wolf cubs are also called pups.

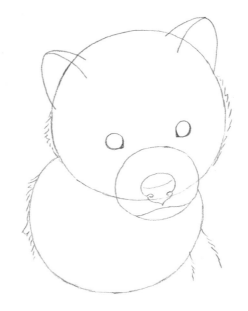

1 Sketch and Transfer
Sketch the basic shape of the wolf cub with the 2B pencil on the tracing paper. Once you are happy with the sketch, transfer only the necessary lines to the paper, making sure to use the less textured side of the white paper. To transfer the design, use either the transfer paper, or tape the drawing to a window with the light shining through, so you can see the design through the paper.

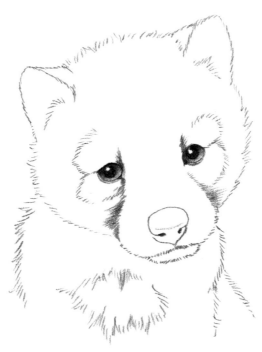

2 Develop the Drawing
Refine the drawing by adding delicate fur lines with the 2B pencil. Draw the eye, leaving the highlight as white paper. Blend with a tortillion.

CLICK ERASERS

Click erasers are very useful, as they can be easily cut with a craft knife when you need a sharp edge to your eraser. Either cut the top off flat, or shape it into a point. Some artists sharpen them in a pencil sharpener, but I find that unsatisfactory as the point stays rounded.

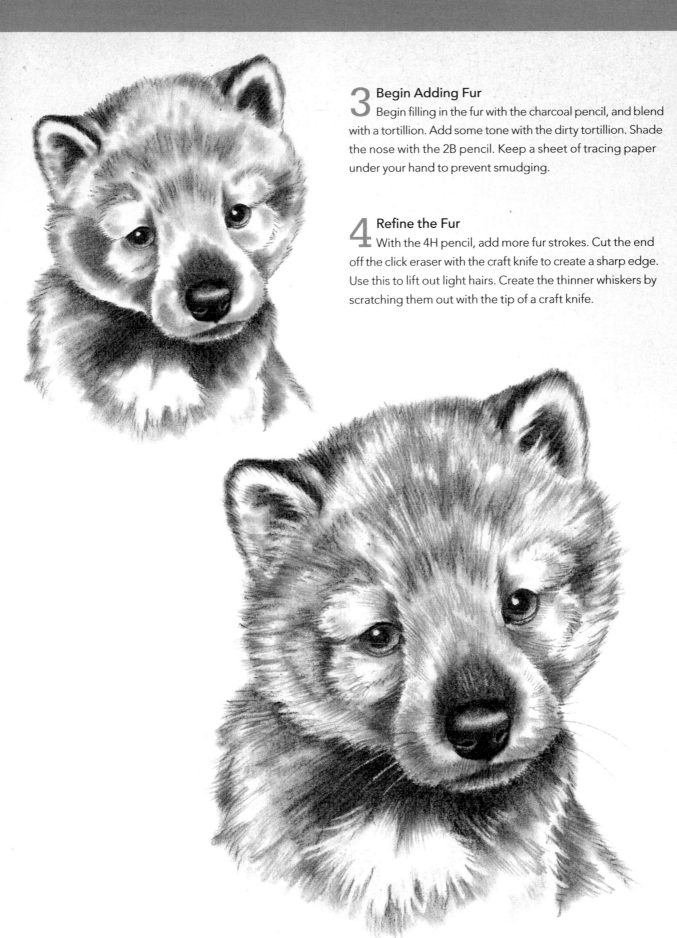

3 Begin Adding Fur
Begin filling in the fur with the charcoal pencil, and blend with a tortillion. Add some tone with the dirty tortillion. Shade the nose with the 2B pencil. Keep a sheet of tracing paper under your hand to prevent smudging.

4 Refine the Fur
With the 4H pencil, add more fur strokes. Cut the end off the click eraser with the craft knife to create a sharp edge. Use this to lift out light hairs. Create the thinner whiskers by scratching them out with the tip of a craft knife.

43

west highland white terrier

materials

SURFACE
bristol board (vellum)

PENCILS
GRAPHITE PENCILS:

2B

4H

PASTEL PENCIL:

French Grey

OTHER SUPPLIES
click eraser

craft knife

facial tissue

tortillions

tracing paper

transfer paper

NATURAL-LOOKING WHITE FUR

When using an eraser to create white fur, it's easy to make the fur lines look too even and regular. Vary the pressure on the eraser and the spacing of the fur lines for a more natural appearance.

This fluffy little angel is named Lola and belongs to my neighbor. I love Westies because they look like little stuffed animals and their noses look like licorice! This white puppy will need lots of tone added with a tortillion that already has a buildup of graphite. A nice white fur effect can be created by "drawing" with an eraser and lifting the hairs out of areas of tone.

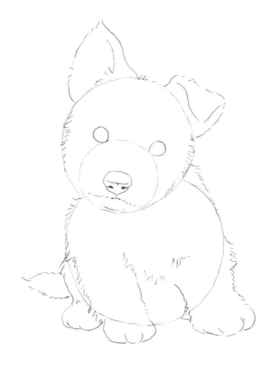

1 Sketch and Transfer
This puppy has a sturdy, round body that is based on circles. With the 2B pencil, draw the puppy on the tracing paper until you are satisfied with your sketch. Transfer only the most necessary lines onto the bristol board.

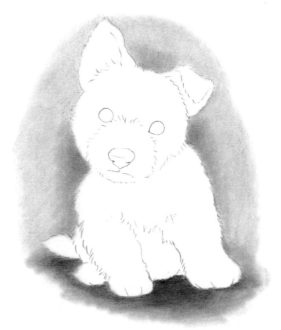

2 Add Tone
Add tone around the puppy with the French Grey pastel pencil and blend with a facial tissue wrapped around your finger. Create a darker shadow under and around the puppy with the 2B pencil and blend with a tortillion.

3 Draw the Face

Begin by drawing the eyes, nose and mouth with the 2B pencil and blending with the tortillion. Draw around the highlights so they remain as plain paper. Start adding fur strokes with the 4H pencil. Scratch out a few hairs overlapping the eyes with the craft knife.

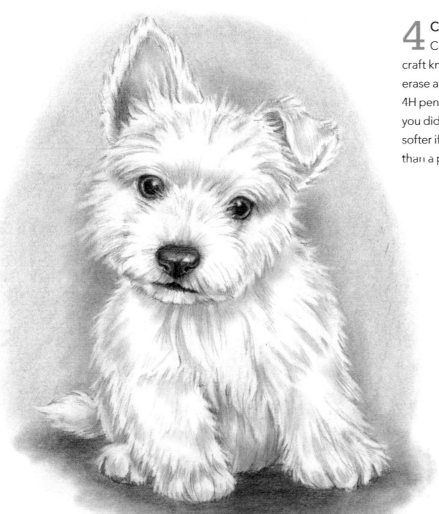

4 Continue Developing the Fur

Cut the end off the click eraser with the craft knife to create a sharp edge. Use this to erase and "draw" white fur. Touch up with the 4H pencil. Continue adding fur to the body as you did on the head. Some of the fur will look softer if you draw it with a dirty tortillion rather than a pencil.

5 Finish

Finish drawing fur on the legs, feet and tail as you did before. The feet are mostly covered by fur, but there should be a slight indication of toes.

boxer

materials

SURFACE
bristol board (vellum)

PENCILS
GRAPHITE PENCIL:

2B

PASTEL PENCIL:

French Grey

OTHER SUPPLIES
click eraser

craft knife

facial tissue

tortillions

tracing paper

transfer paper

Sometimes it's fun to try to capture a playful pose when drawing puppies. Working from photographs comes in handy here, and enables you to "freeze" the pose. Boxers have short, smooth fur that needs lots of blending, so have some tortillions or other blending tools handy, and remember to keep a sheet of tracing paper under your hand to prevent smudging.

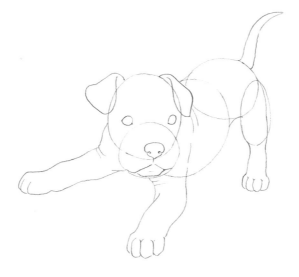

1 Sketch and Transfer
This puppy's body is based on a series of ovals. Work out your sketch on the tracing paper, using the 2B pencil and either the grid method or basic shapes method. Transfer only the most necessary lines to the bristol board. Some of the lines are inside the ovals, so you will not need to transfer the sketched oval shapes there.

LIFTING WITH AN ERASER

When using an eraser to lift lines out of your drawing, don't forget to brush away the eraser crumbs with a horsehair drafting brush, rather than using your hand. This will prevent streaks and smudges.

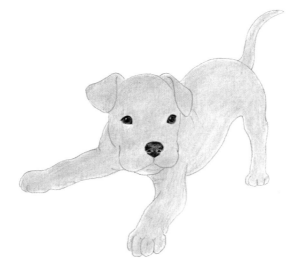

2 Lay In the Basic Tones
Fill in the puppy's body with the French Grey pencil and blend with a facial tissue wrapped around your finger. You will get smoother tones if you hold the pencil on its side rather than coloring with the tip. Fill in the nose and eyes with the 2B pencil. Leave the eye highlights as white paper.

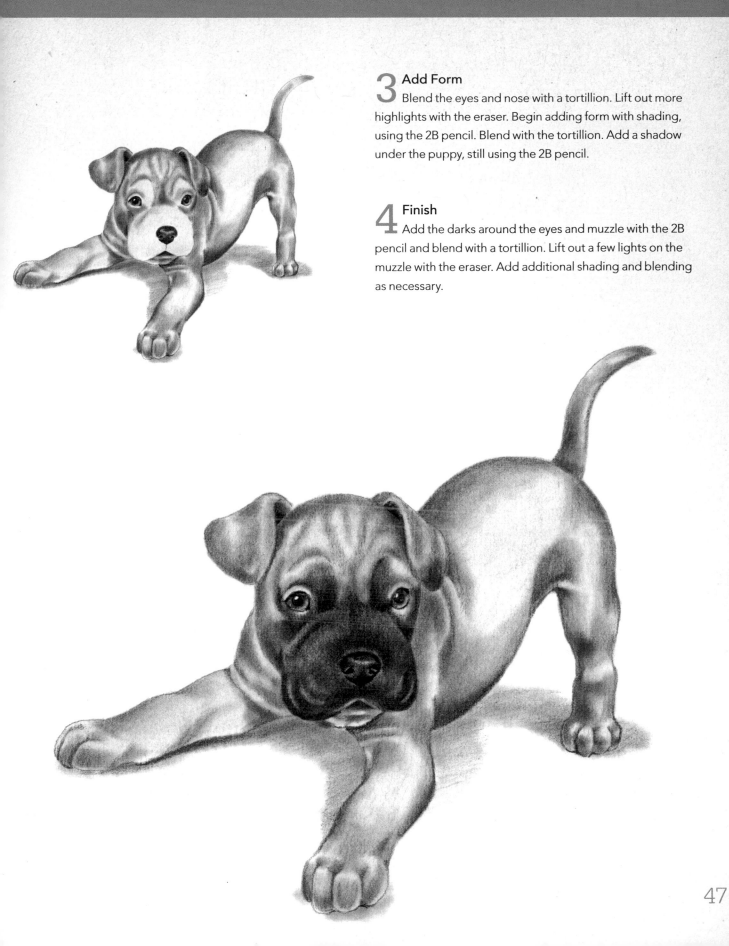

3 Add Form

Blend the eyes and nose with a tortillion. Lift out more highlights with the eraser. Begin adding form with shading, using the 2B pencil. Blend with the tortillion. Add a shadow under the puppy, still using the 2B pencil.

4 Finish

Add the darks around the eyes and muzzle with the 2B pencil and blend with a tortillion. Lift out a few lights on the muzzle with the eraser. Add additional shading and blending as necessary.

springer spaniel

materials

SURFACE
bristol board (vellum)

PENCILS
GRAPHITE PENCILS:

2B

4H

OTHER SUPPLIES
click eraser

craft knife

tortillions

tracing paper

transfer paper

This puppy belonged to my neighbor. Springer spaniels have soft, silky fur. The hair becomes longer and wavier on an adult, especially on the ears. Springers were developed as working dogs, specifically for hunting, and have very intelligent faces. Their tails are sometimes docked so they don't get caught and tangled in brambles and thorns when hunting.

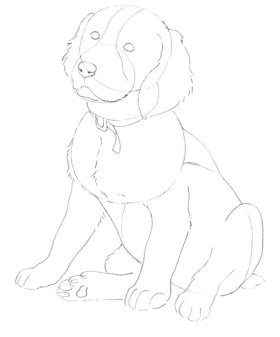

1 Sketch and Transfer
Using a 2B pencil, sketch the puppy on tracing paper, using either the basic shapes method or the grid method. Once you are satisfied with the drawing, transfer only the necessary lines to the bristol board.

PROTECT YOUR DRAWING

If you are right-handed, work from left to right so that your hand will not be resting on a completed area of the drawing (and vice versa if you are left-handed). This, in addition to having a sheet of tracing paper under your hand, will help you avoid smudging the drawing.

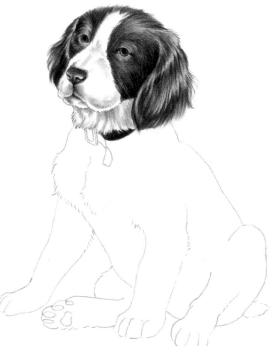

2 Add Tone
With the 2B pencil, add the darkest tones on the head. Use a 4H pencil for the white fur, and add the softest tone with a tortillion that already has a buildup of graphite. Pick out some lights with the click eraser. Cut the end off the eraser with a craft knife so you have a sharp edge to help you "draw" with the eraser and create fine lines.

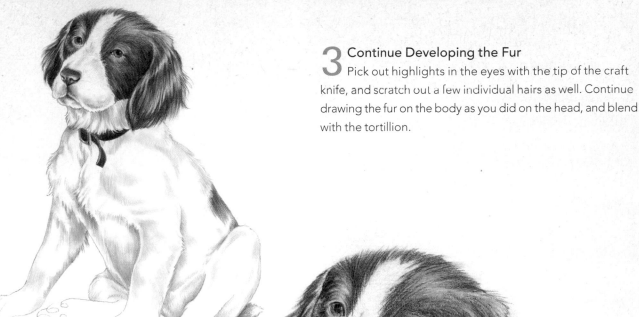

3 Continue Developing the Fur

Pick out highlights in the eyes with the tip of the craft knife, and scratch out a few individual hairs as well. Continue drawing the fur on the body as you did on the head, and blend with the tortillion.

4 Finish

Add a little shading under the puppy with the 2B pencil and blend with the tortillion. Finish drawing the legs and feet with the 4H pencil and blend.

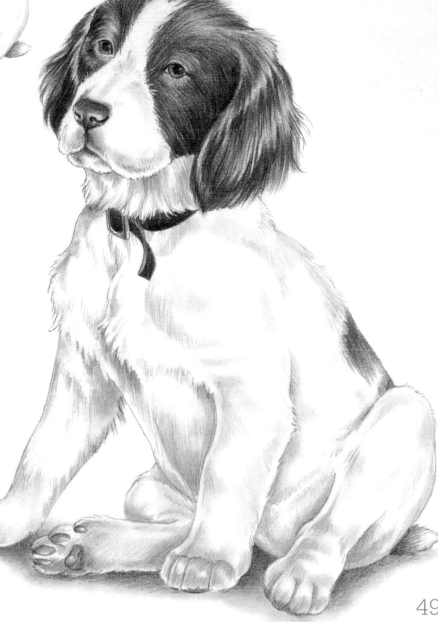

golden retriever

materials

SURFACE
bristol board (vellum)

PENCILS
GRAPHITE PENCIL:

2B

DERWENT PASTEL PENCILS:

Brown Ochre

Burnt Sienna

French Grey

DERWENT STUDIO COLOUR PENCILS:

Chinese White

Copper Beech

Golden Brown

Gunmetal

Ivory Black

Raw Umber

Terracotta

OTHER SUPPLIES
click eraser

craft knife

facial tissue

tortillions

tracing paper

transfer paper

SOFT PASTELS

If your base color appears
especially streaky, try using
a soft chalk pastel instead of
the pastel pencil. Soft pastels
blend more easily than pencils
because they have less binder.

This retriever puppy has very soft, fluffy fur. Drawing animals with this much fur
can be a challenge, as it is easy to lose the body shape under all that hair! Try to
imagine the solid muscles underneath as you create your drawing.

1 Sketch and Transfer
Using either the grid method or the
basic shapes method, create a sketch of the
puppy with a 2B pencil on tracing paper.
Lightly transfer only the most necessary
lines to the bristol board.

Alternatively, tape your sketch to a win-
dow with the light shining through. Tape
the bristol board over the top and use the
Raw Umber pencil to trace the lines that
show through.

2 Fill in Color
Touch up the sketch lines if necessary
with the Raw Umber pencil. Fill in the base
color with the Burnt Sienna pastel pencil and
blend with a facial tissue wrapped around
your finger. Add a little more tone to the
ears. Don't worry if the color is streaky; you'll
be drawing over it.

3 Add Form

Begin adding form with the Brown Ochre pastel pencil, starting at the head and working your way down. Blend with a tortillion. Fill in the eyes with the Copper Beech pencil, and the nose with Gunmetal. Keep a sheet of tracing paper under your hand to prevent smudging.

4 Add Detail to the Face

Add details to the eyes, nose and mouth with the Ivory Black pencil. Scratch out highlights with the craft knife. Blend the highlights with a little Chinese White. Add more details to the mouth with Copper Beech. Begin adding fur strokes with Raw Umber. Use firmer pressure for the darker strokes on the ears and around the muzzle.

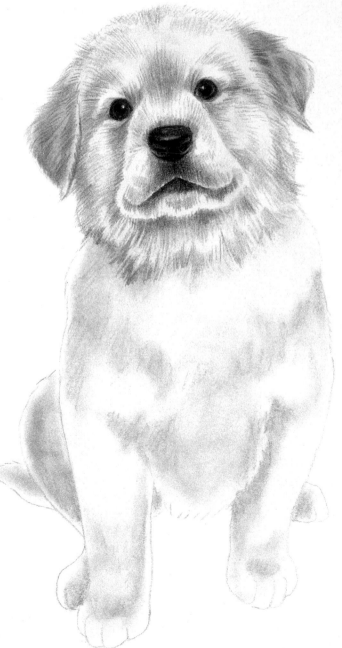

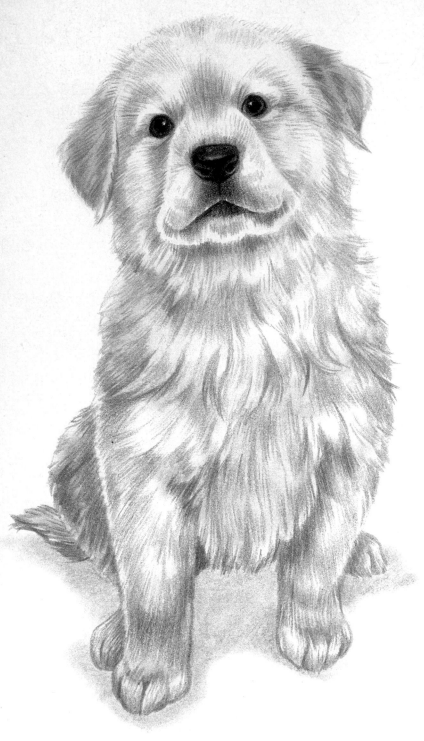

5 Continue Adding Fur

Continue drawing fur strokes with the Raw Umber pencil. Remember to keep a sharp point on your pencil. Lay in a shadow under the puppy with the French Grey pastel pencil and blend with a tortillion.

6 Add Depth and Details

Use the Gunmetal pencil to darken the shadow under the puppy, and blend with a tortillion. Add more fur strokes with the Golden Brown pencil. Add a few touches to the ears and tail with Terracotta.

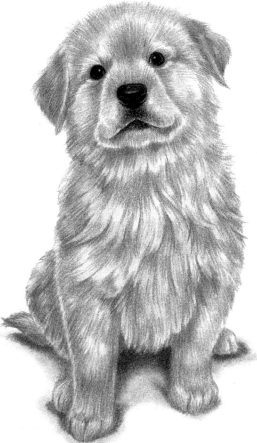

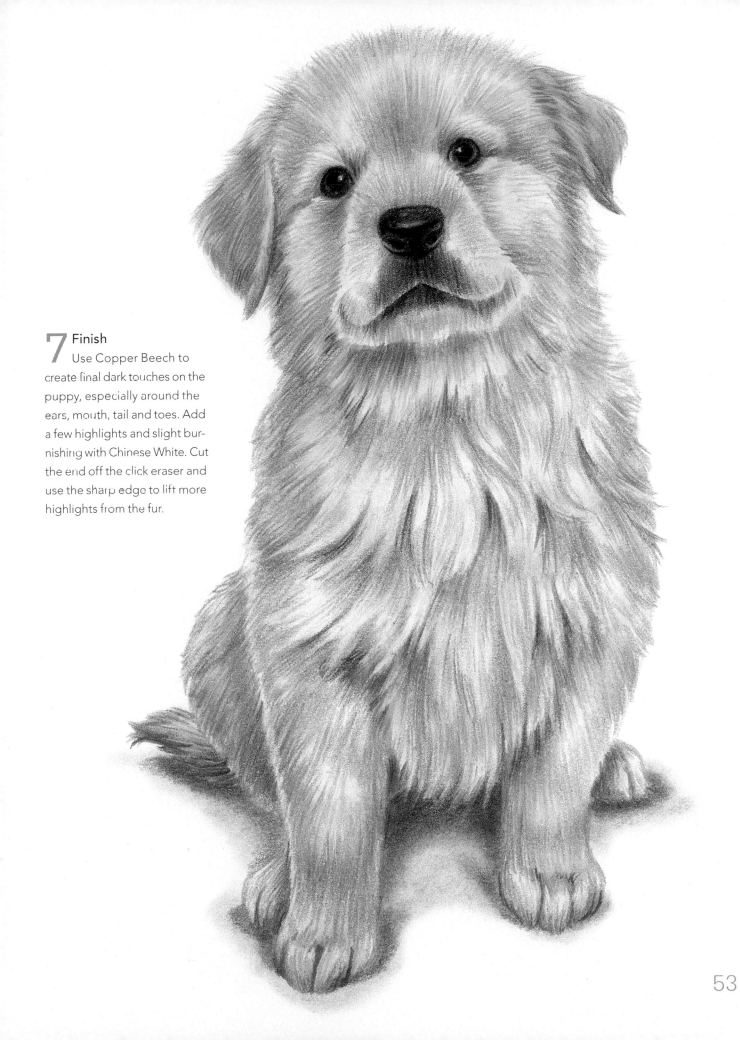

7 Finish
Use Copper Beech to create final dark touches on the puppy, especially around the ears, mouth, tail and toes. Add a few highlights and slight burnishing with Chinese White. Cut the end off the click eraser and use the sharp edge to lift more highlights from the fur.

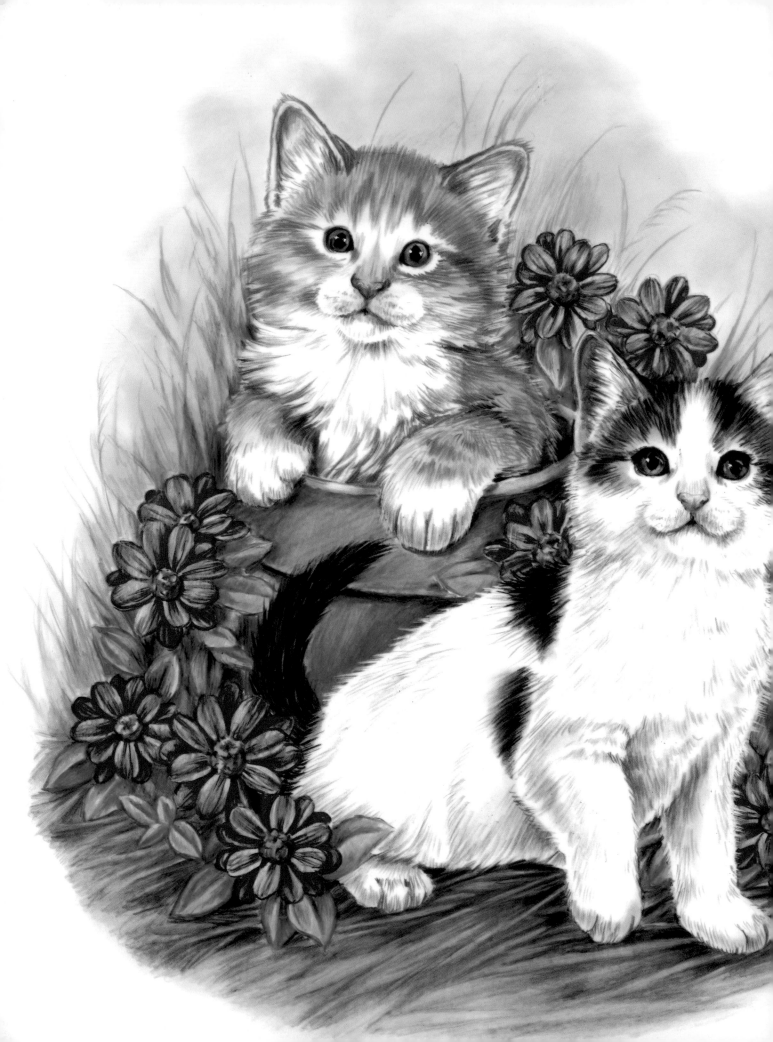

Kittens

Kittens are among my favorite subjects to draw, which is a little odd since I am extremely allergic to them! Maybe my pencil strokes can make up for not being able to stroke them with my hand. There are many different feline types, although the differences among breeds are not as extreme as they are in the dog family. When drawing kittens, it is essential to have some dirty tortillions on hand, especially for adding tone to the white areas without having to draw pencil lines there first.

For the kitten drawing at left, I used some reference photos given to me by the Lakeland Animal Shelter in Elkhorn, Wisconsin. At certain times of year, animal shelters have a great influx of kittens that need homes, so they often post photos of them to draw in potential owners. I photographed the pink zinnias in my own garden. Feel free to combine several different reference sources when you are creating your compositions, as very rarely will you have a single photo that contains everything you might need.

To begin the drawing, I filled in the first layer of colors using medium blue and green pastels for the sky and grass, applying them with sponge applicators, and a medium brown pastel for the ground and the brown patches on the foreground kitten. For the ginger kitten I used raw sienna pastel. Magenta and green colored pencils were used for the flowers and leaves, and a turquoise blue pencil for the flower pot.

Next, I began adding details. I used various greens and yellow ochre to add grass and leaves, and dark brown, yellow ochre and olive green for the ground. For the kittens I used dark brown and golden brown colored pencils to add fur, and filled in their eyes with olive green with touches of blue. Pupils were added with black colored pencil, and highlights with small dots of Titanium White watercolor and a small brush. A few light hairs were scratched out with a craft knife. The flowers centers were drawn with golden brown, with dark brown details, and the flower petals were detailed with magenta and alizarin crimson pencils. I shaded the flower pot with cobalt blue and dark gray.

keys to drawing kittens

Softness is the main element to strive for when drawing kittens. I use a lot of pastel pencils, charcoal and blending tools to help achieve the look of very soft fur. Paying too much attention to drawing individual hairs can make the kitten look spiky. Here are some things to keep in mind when working on your kitten drawings.

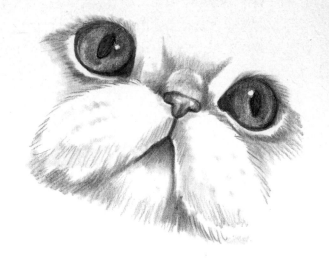

Persian Kitten

Persian kittens (above) differ from other kittens in that they have flattened muzzles, which can give them a grumpy expression if you are not careful when drawing them. Pay special attention to their eyes as well. I find that if you draw a Persian kitten looking upwards, it looks more appealing than if the kitten is looking down or straight ahead. Persians have extremely soft fur, so you will want to add tone with a dirty tortillion in some areas.

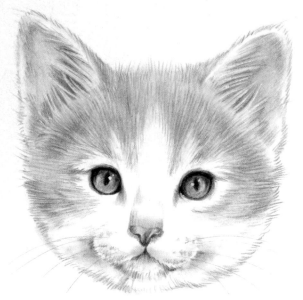

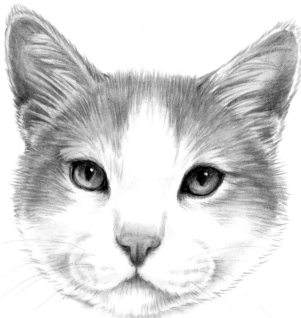

Kitten versus Cat Proportions

A kitten's features (above left) are different from an adult cat's (left) in relation to the size of the head. The nose and mouth are more delicate, while the ears seem larger. When drawing baby animals, many people make the mistake of turning them into tiny adults, so it's important to pay attention to the differences in proportion.

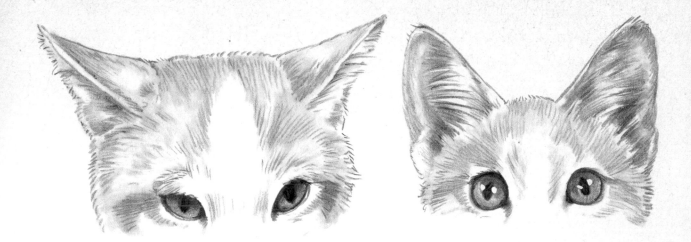

Kitten Ears

A kitten's ears are a good indicator of its mood. The ears on the left side of this illustration are swiveled to show the back sides. This indicates irritation and possibly aggression. The ears on the right are facing forward in an alert, contented position. Pay careful attention to your subject's mood while you are photographing it. If the kitten's ears begin to go back, it means he is uncomfortable with the unfamiliar situation of having a camera pointed at him. Either stop and try to soothe him with affection or treats, or put the camera away until a time when the subject is feeling more relaxed. It's easy to get caught up in the excitement of getting "the perfect shot," and forget that the subject may be getting frightened or irritated.

Sleeping Kittens

If you want to try sketching from life, rather than from a photograph, you may want to wait until those little bundles of energy fall asleep. That is the only time they will be still enough for more than a quick gesture drawing! This sketch was done very quickly with a charcoal pencil.

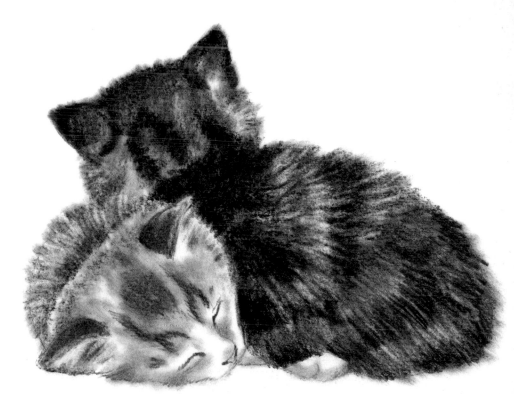

white kitten

materials

SURFACE
bristol board (vellum)

PENCILS
GRAPHITE PENCILS:

2B

4H

PASTEL PENCIL:

French Grey

OTHER SUPPLIES
click eraser

craft knife

facial tissue

small round paintbrush

Titanium White
 watercolor paint

tortillions

tracing paper

transfer paper

Drawing white animals is always a challenge because you don't want them to end up looking dirty by adding too much shading. I added some tone to the background of this drawing so the white hairs could be lifted by "drawing" them with an eraser. I used a pastel pencil for the tone because it gives a smoother result, whereas charcoal can leave streaks.

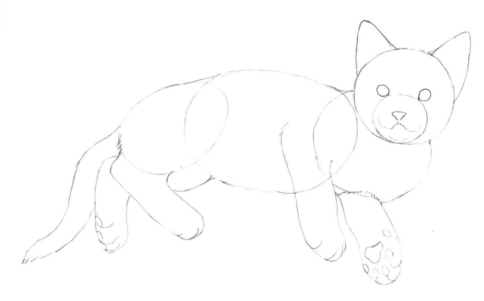

1 Sketch and Transfer
With a 2B pencil, create a sketch on tracing paper using your preferred method. Lightly transfer only the most necessary lines to bristol board, either with transfer paper or by taping the sketch to a window.

2 Refine the Drawing
Refine the sketch with your 2B pencil, creating delicate fur lines. Begin adding shading with a dirty tortillion. Much of the white fur will be created in Step 4 by lifting out tone with an eraser, using the eraser like a pencil.

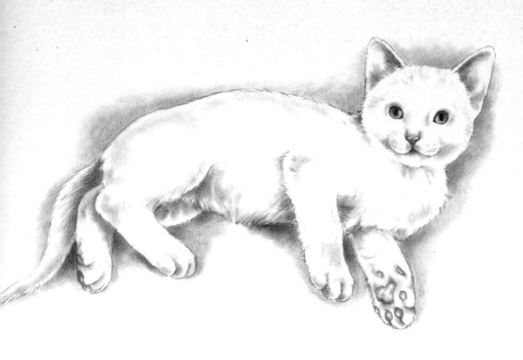

3 Add More Shading

With a French Grey pastel pencil, add tone around the kitten and blend with a facial tissue wrapped around your finger. Add a few darker areas of shadow with the 2B pencil.

With a 4H pencil, detail the paw pads, nose and mouth. Continue developing the fur with delicate strokes of the 2B pencil and the dirty tortillion.

4 Finish

Use a craft knife to cut off the end of a click eraser to create a sharp edge. "Draw" white fur lines into the shaded areas with the edge of the click eraser. Add highlights to the eyes with white watercolor paint. Draw whiskers with a sharp 4H pencil.

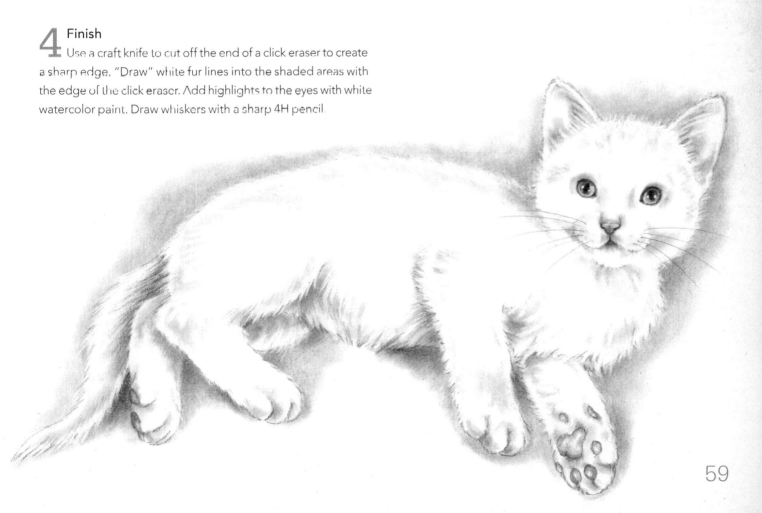

tabby

materials

SURFACE

Canson Mi-Teintes
paper (white)

PENCILS

GRAPHITE PENCIL:

2B

CHARCOAL PENCIL:

medium

OTHER SUPPLIES

click eraser

craft knife

small round paintbrush

Titanium White
watercolor paint

tortillions

tracing paper

transfer paper

For this drawing, you'll be adding quite a bit of tone with a tortillion that already has a buildup of graphite. This is an effective way of adding shading to soft white fur without pencil strokes. Be particularly gentle when adding tone to the mouth and muzzle, as you want these areas to have soft shapes without looking dirty.

1 Sketch and Transfer
On your tracing paper, sketch the basic shapes of the kitten with the 2B pencil. Once you are happy with the sketch, transfer only the necessary lines to the white paper, making sure to use the less textured side of the paper.

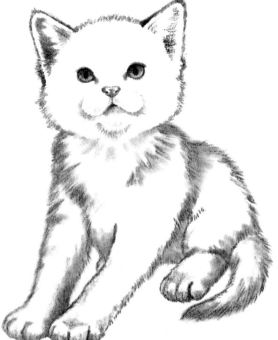

2 Refine the Drawing
With the charcoal pencil, begin to refine the drawing. Use the 2B drawing pencil for the facial features. Blend with a tortillion. Use the dirty tortillion to add light tone.

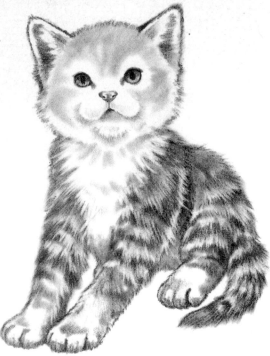

3 Fill In the Fur

With the dirty tortillion, add soft tone to the face. Add stripes to the body with the charcoal pencil and blend. It helps to draw the mid-tones first, then add the darker stripes. Use the eraser to pick out lighter fur. If necessary, cut the end of the eraser with a craft knife to create a sharp edge that you can use to "draw" the white stripes.

4 Finish

Add more tone and stripes to the kitten's face, and pick out lighter fur with the eraser. Use the dirty tortillion to indicate a shadow under the kitten. With the white watercolor paint and a small round paintbrush, place highlights in the eyes. Finally, use a very sharp 2B pencil to add whiskers.

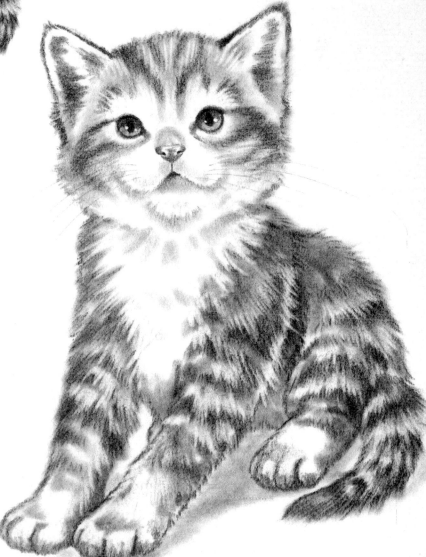

siamese

materials

SURFACE

Canson Mi-Teintes
paper (white)

PENCILS

GRAPHITE PENCIL:

2B

CHARCOAL PENCIL:

medium

OTHER SUPPLIES

click eraser

craft knife

small round paintbrush

Titanium White
watercolor paint

tortillions

tracing paper

transfer paper

Siamese cats are recognizable for their distinctive color pattern. They have blue eyes and short, sleek fur. They also can be rather noisy, and meow more than many other breeds. A dirty tortillion will be useful for adding soft tones.

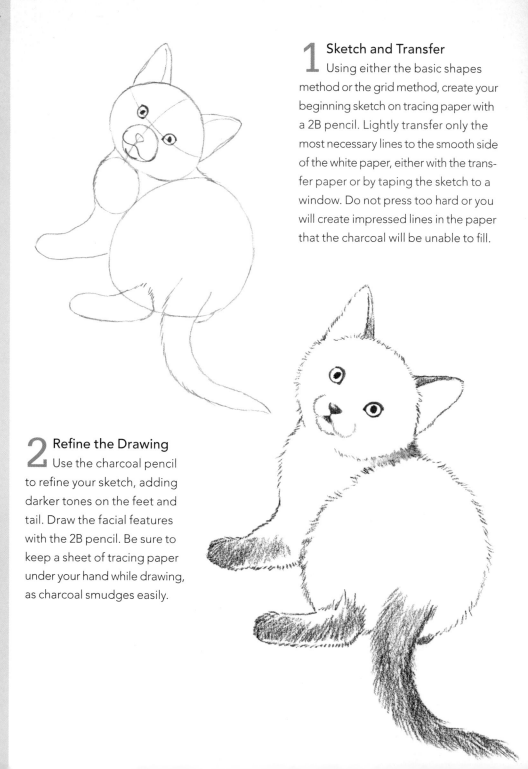

1 Sketch and Transfer
Using either the basic shapes method or the grid method, create your beginning sketch on tracing paper with a 2B pencil. Lightly transfer only the most necessary lines to the smooth side of the white paper, either with the transfer paper or by taping the sketch to a window. Do not press too hard or you will create impressed lines in the paper that the charcoal will be unable to fill.

2 Refine the Drawing
Use the charcoal pencil to refine your sketch, adding darker tones on the feet and tail. Draw the facial features with the 2B pencil. Be sure to keep a sheet of tracing paper under your hand while drawing, as charcoal smudges easily.

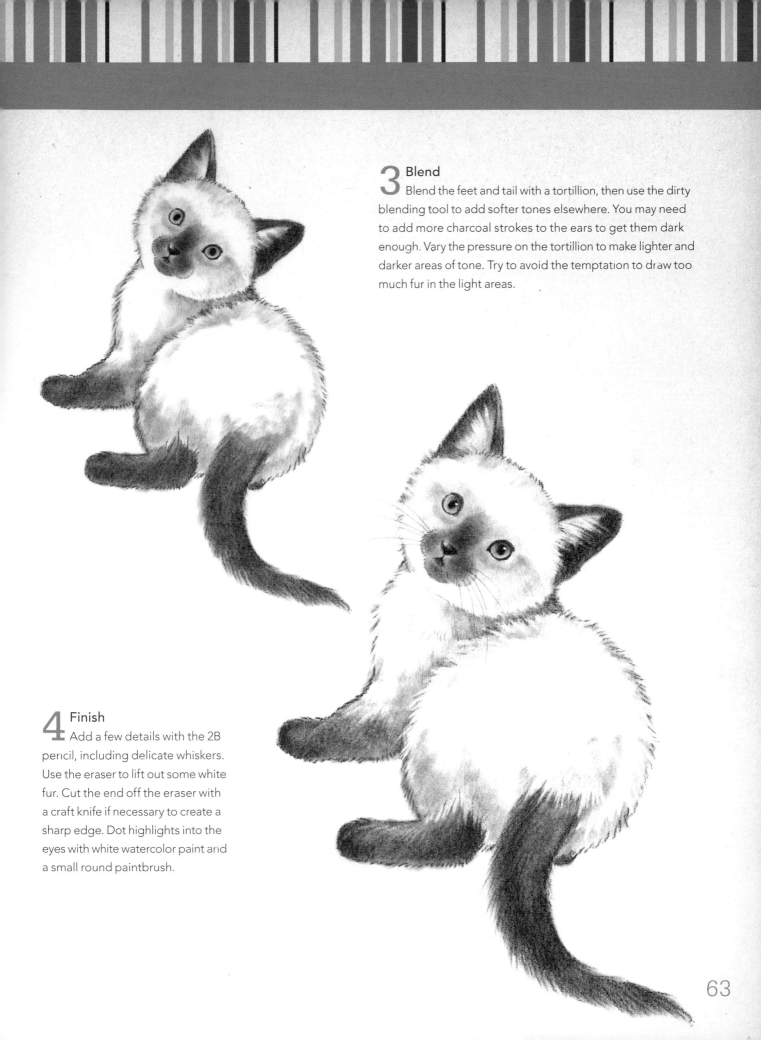

3 Blend

Blend the feet and tail with a tortillion, then use the dirty blending tool to add softer tones elsewhere. You may need to add more charcoal strokes to the ears to get them dark enough. Vary the pressure on the tortillion to make lighter and darker areas of tone. Try to avoid the temptation to draw too much fur in the light areas.

4 Finish

Add a few details with the 2B pencil, including delicate whiskers. Use the eraser to lift out some white fur. Cut the end off the eraser with a craft knife if necessary to create a sharp edge. Dot highlights into the eyes with white watercolor paint and a small round paintbrush.

calico

materials

SURFACE
bristol board (smooth)

PENCILS
GRAPHITE PENCILS:
2B
4B
4H

OTHER SUPPLIES
kneaded eraser
small round paintbrush
Titanium White
 watercolor paint
tortillions
tracing paper
transfer paper
white eraser

Calico cats are nearly always female, and they have fur that is a combination of white, black, brown or cinnamon. Cats with a brindle coat with no white are called "tortoiseshell."

1 Sketch and Transfer
Lay out the line drawing on tracing paper, using either the basic shapes method or the grid method, and a 2B pencil. Fix mistakes and make any necessary adjustments, and when you are happy with the line drawing, lightly transfer only the necessary lines to the bristol board.

2 Begin the Fur Markings
With the 2B pencil, begin laying in the fur markings on the head. Vary the pressure on the pencil to create lighter and darker marks. Draw the pupils and outline of the eyes, and shade the tops of the eyeballs. Blend with a tortillion. Dot in highlights with white watercolor paint and a small round brush.

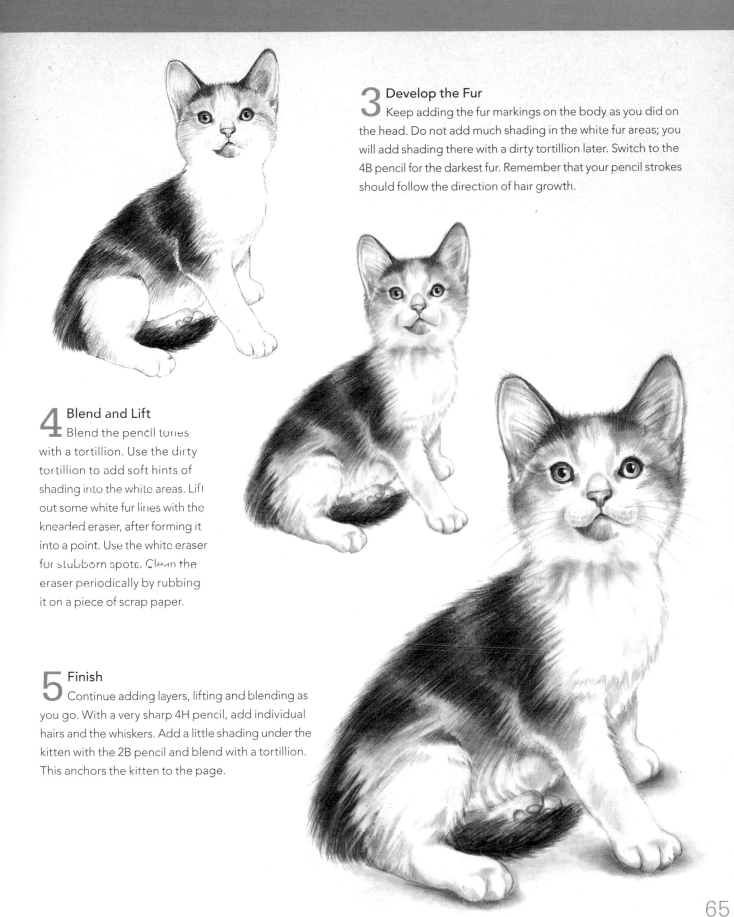

3 Develop the Fur

Keep adding the fur markings on the body as you did on the head. Do not add much shading in the white fur areas; you will add shading there with a dirty tortillion later. Switch to the 4B pencil for the darkest fur. Remember that your pencil strokes should follow the direction of hair growth.

4 Blend and Lift

Blend the pencil tones with a tortillion. Use the dirty tortillion to add soft hints of shading into the white areas. Lift out some white fur lines with the kneaded eraser, after forming it into a point. Use the white eraser for stubborn spots. Clean the eraser periodically by rubbing it on a piece of scrap paper.

5 Finish

Continue adding layers, lifting and blending as you go. With a very sharp 4H pencil, add individual hairs and the whiskers. Add a little shading under the kitten with the 2B pencil and blend with a tortillion. This anchors the kitten to the page.

long-haired kitten

materials

SURFACE
Canson Mi-Teintes
paper (white)

PENCILS

GRAPHITE PENCIL:

2B

DERWENT PASTEL PENCILS:

Spectrum Blue 32B

Burnt Sienna

Crimson Lake 20F

Sepia

Prussian Blue

DERWENT STUDIO COLOUR PENCILS:

Chinese White

Copper Beech

Golden Brown

Ivory Black

Raw Umber

Terracotta

OTHER SUPPLIES

click eraser
 or eraser pencil

cotton swabs

craft knife

facial tissue

tortillions

tracing paper

transfer paper

I love drawing long flowing hair, and this kitten was such a beauty that I couldn't resist. However, it is easy for the muscles and body shape of an animal to get lost under all that hair, so spend plenty of time on your sketch, imagining how the underlying shapes would look.

1 Sketch and Transfer
With a 2B pencil, sketch the kitten on tracing paper, using either the basic shapes method or the grid method. When you are satisfied with the sketch, transfer only the most necessary lines onto the Canson paper. If you are using a window or a light box for tracing, you can skip to step 2 and fill in with color so you don't have pencil lines. Otherwise, make your transferred lines as light as possible by lifting with an eraser.

TRACE LIGHTLY

When transferring a drawing that you will create in color, it is important to transfer the drawing lightly. If you press too hard, you will make indented lines that are impossible to cover with colored pencils. You could also end up with dark graphite lines showing through the colored areas, because erasing does not lift dark transferred lines completely.

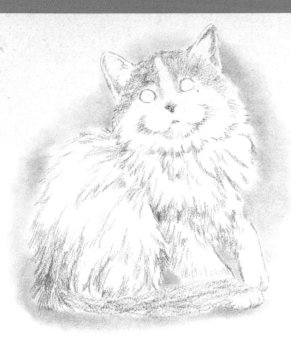

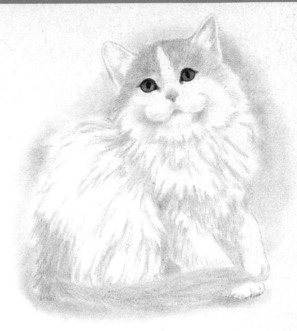

2 Fill In with Color
Add background around the kitten with a Spectrum Blue 32B pastel pencil ("32B" refers to intensity of color, as this color comes in light, medium and full-strength options; 32B is medium intensity). Blend with a facial tissue or tortillion. For the fur, use Burnt Sienna pastel pencil for the orange hair, Sepia pastel pencil to shade the white hair, and Terracotta colored pencil for the nose and mouth.

3 Blend Fur and Add Eyes
Blend the fur with tortillions. Fill in the eyes with a Golden Brown colored pencil. Add pupils with Ivory Black and the eye rim with Ivory Black and Copper Beech colored pencils. Remember to keep a piece of tracing paper under your hand to prevent smudging.

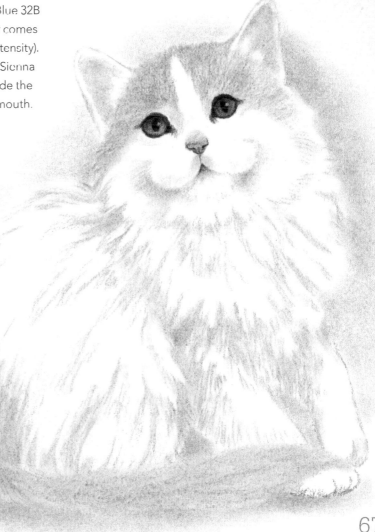

4 Add Facial Details
Scratch out the highlights in the eyes with a craft knife and burnish with the Chinese White colored pencil. Add details to the nose and mouth with the Terracotta and Copper Beech colored pencils. Rub a clean tortillion or cotton swab across the Crimson Lake 20F pastel pencil and use the pigment you pick up to add pink touches to the ears and below the nose.

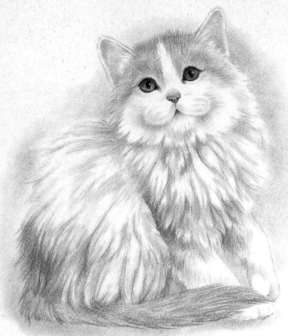

DRAWING WHITE HAIR

When drawing white hair, you actually need to draw the shading between the locks of hair. This is called "negative drawing." If you try to draw the individual hairs, the fur will come out looking dirty and unnatural.

5 Develop the Fur

Begin developing the fur with delicate strokes of the Raw Umber colored pencil, remembering to always stroke in the direction of fur growth. Rotate your paper to make this easier if necessary. Blend slightly with a tortillion. Do not rub too hard or you will lift the pastel pigment off the paper.

6 Add More Details

With the Prussian Blue pastel pencil, add shading under the kitten and blend. Continue developing the fur with colored pencils in Golden Brown, Terracotta and Copper Beech. With the click eraser, lift out some white hairs. Cut off the end of the eraser with a craft knife to create a sharp edge if necessary. You can substitute an eraser pencil for this if desired.

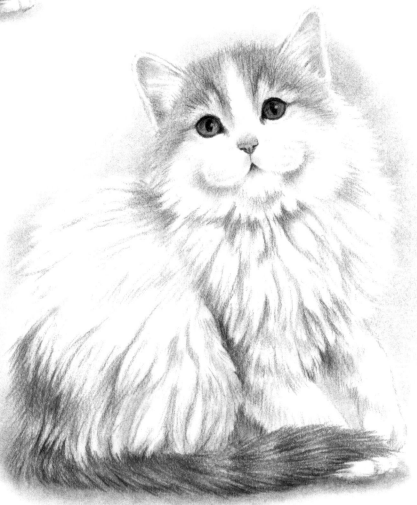

7 Finish

With the Chinese White colored pencil, add some lighter strokes to the fur, particularly on the tail. Continue adding fur strokes as necessary. Sharpen the Raw Umber pencil until it has a fine point and draw the whiskers.

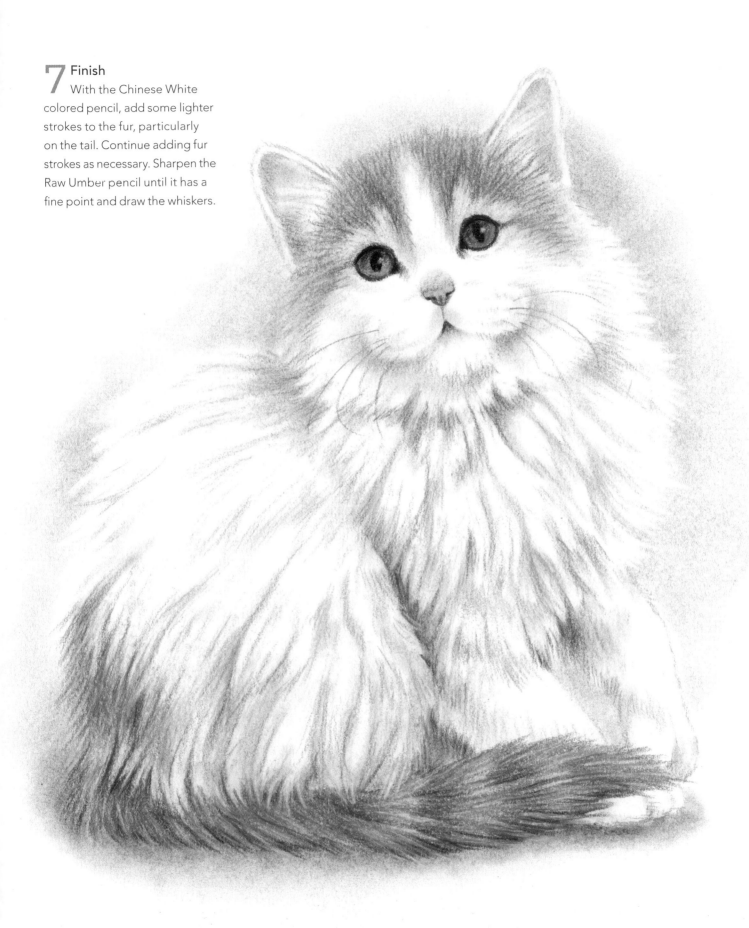

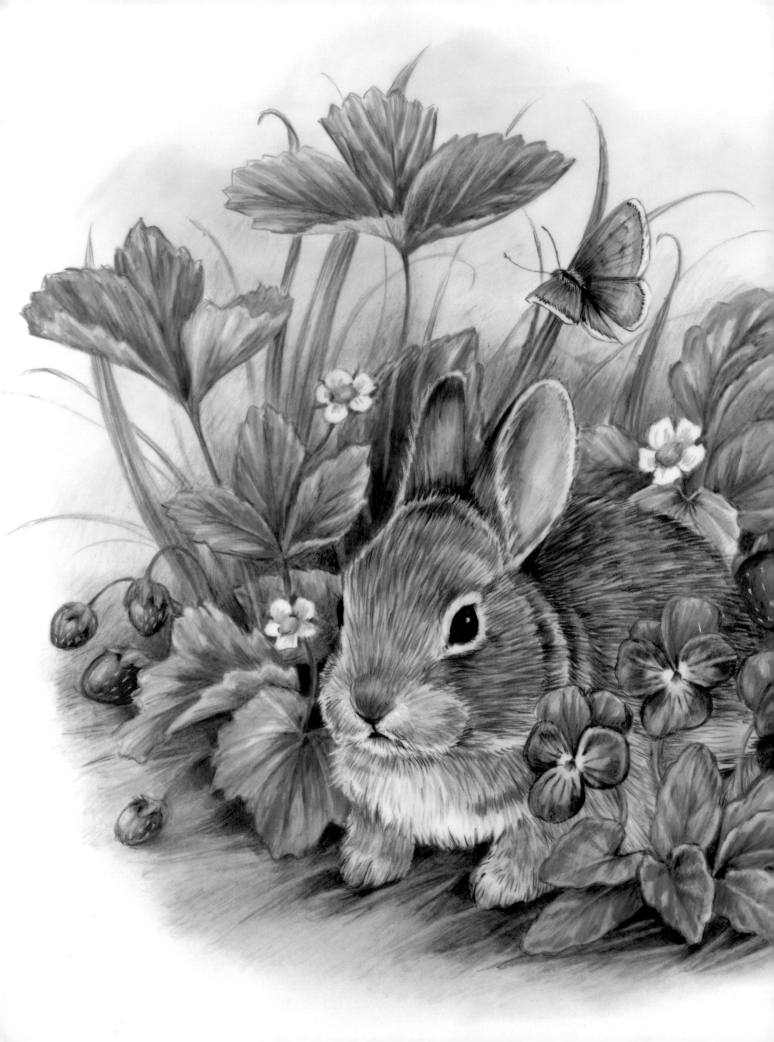

Small Mammals

The small and furry creatures in this chapter are the wild animals that are most common almost everywhere, although you may have to look carefully to find them. Some animals, such as rabbits and mice, have domestic varieties that make popular pets. And foxes and raccoons have adapted themselves well enough that they are a relatively common sight in towns and cities. We see a lot of foxes near our house. One mother fox had a den with her babies next to the post office, which is one of the busiest areas in town!

I photographed the baby bunny at left in my garden, which explains why all the strawberries kept mysteriously disappearing! First, I filled in the initial layers of colors in pastel using light green, olive green, and raw umber for the background, and burnt sienna for the bunny, applying the colors with a sponge applicator (similar to the technique shown on page 13). For the leaves I used a medium green colored pencil, red-orange colored pencil for the berries, and lavender for the flowers.

Next, I used various green and brown colored pencils, including olive green and yellow ochre for the grass and details on the leaves. The centers of the strawberry blossoms are golden yellow with brown details, and the petals are shaded with light gray. The strawberries are drawn with red and alizarin crimson colored pencils, with glazes of yellow over the lighter areas. The seeds are scratched out with a craft knife, then colored in with yellow.

For the bunny, I added fur details with various browns, and scratched out some of the light hairs with a craft knife. I also used a Chinese White colored pencil to add density to the light hairs around the eye, muzzle, and breast. The inside of the ear was filled in with a light pink colored pencil, and shading was added with raw sienna and brown.

The pansies received details with lavender, purple, and magenta colored pencils, with dark blue lines and yellow centers. The butterfly was drawn with various blues, plus brown and black details, with the lights scratched out with the craft knife.

keys to drawing small mammals

The small mammals we'll be studying in this section, such as bunnies, mice, foxes and raccoons, all have different fur types and it's important to keep this in mind when drawing them. Mice, for example, have short, smooth fur, while a raccoon's fur is coarse and thick.

Eye position is also important, as foxes and raccoons have forward facing eyes, while rabbits and mice have eyes placed more to the sides.

Ticked Fur (above)
Raccoons and wild rabbits have fur that looks "salt-and-pepper" due to the bands of dark and light color on each hair. This is called "ticked" fur. The image above was drawn with a 2B pencil. I varied the amount of pressure for the darks and lights, and made sure the pencil strokes tapered at the ends.

Bushy Fur (left)
The fur on the tails is longer and bushier. Notice that a few of the individual hairs are longer. These are called "guard hairs."

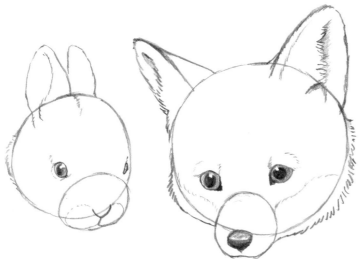

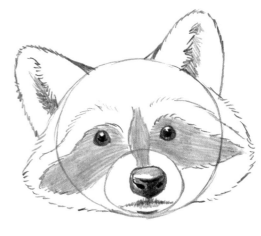

Face Shapes
Baby bunnies, foxes and raccoons all have faces that are based on a circle shape. The football-shaped heads of the fox and raccoon are actually caused by a ruff of fur. The ruff on a baby fox is much smaller than that of an adult.

Noses

Foxes and raccoons have similar looking noses: dark and shiny, with definite highlights. However, up close you can see that the alar fold on the raccoon's nose is higher, and the fox's nose is more dog-like.

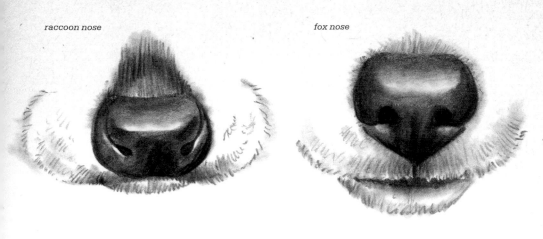

raccoon nose

fox nose

Ears

Raccoons and foxes have similar ears, with thick fur inside, but the raccoon's ears are slightly more rounded.

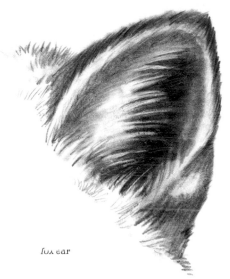

raccoon ear

fox ear

Feet

Many people think rabbits are rodents, but they actually are classed as "lagomorphs." One difference between the two is that rodents pick up and manipulate their food with their front paws, whereas rabbits are unable to do this. Unlike many other mammals, rabbits do not have paw pads on their feet. The dew claw is usually hidden by the fur.

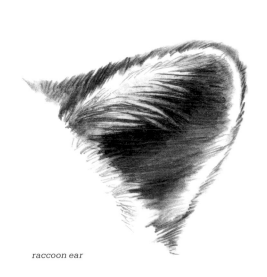
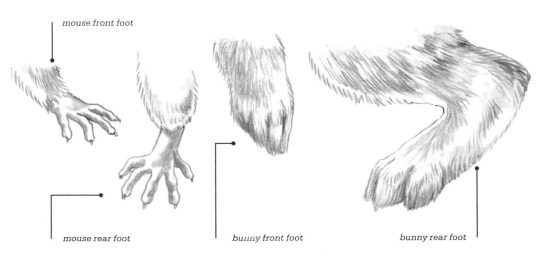

mouse front foot

mouse rear foot

bunny front foot

bunny rear foot

baby bunny

materials

SURFACE
bristol board (vellum)

PENCILS
GRAPHITE PENCILS:

2B

4H

OTHER SUPPLIES
eraser pencil

facial tissue

tortillions

tracing paper

transfer paper

Cottontail rabbits are a familiar (but not always welcome) sight to gardeners almost everywhere. A baby rabbit is called a "bunny," while a baby hare is called a "leveret." Rabbits and other prey animals have eyes positioned on the sides of their heads, to give them wider peripheral vision that helps them watch for predators. Predators, on the other hand, have eyes located more toward the front of the head to help them pinpoint their prey.

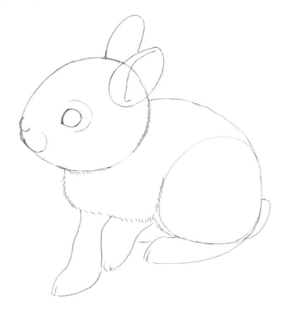

1 Sketch and Transfer
Begin by sketching the bunny onto tracing paper with the 2B pencil, using your preferred method. When the sketch is complete, transfer only the necessary lines lightly onto bristol board.

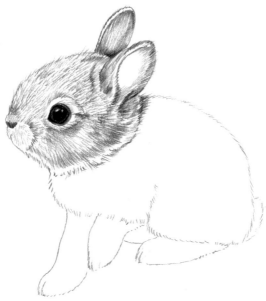

2 Draw the Face
Soften the outlines with delicate fur strokes, using the 2B pencil. Fill in the eye, leaving the highlights as plain paper. Blend with a tortillion and soften the highlights with the eraser pencil. Begin adding fur strokes to the head, still using the 2B pencil. Do not fill in the very center of the ear; you'll do that later with a dirty tortillion.

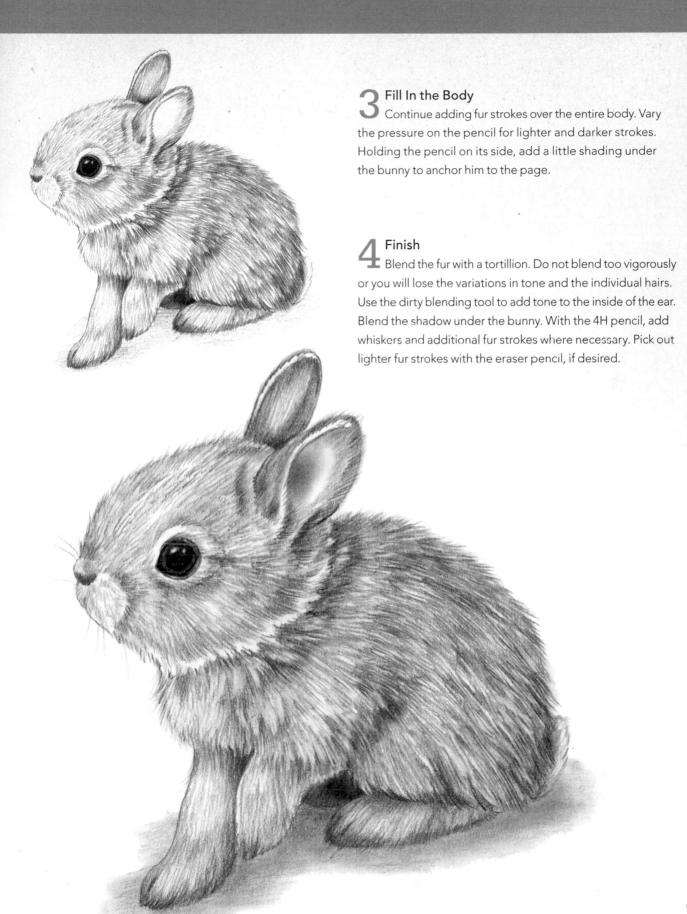

3 Fill In the Body

Continue adding fur strokes over the entire body. Vary the pressure on the pencil for lighter and darker strokes. Holding the pencil on its side, add a little shading under the bunny to anchor him to the page.

4 Finish

Blend the fur with a tortillion. Do not blend too vigorously or you will lose the variations in tone and the individual hairs. Use the dirty blending tool to add tone to the inside of the ear. Blend the shadow under the bunny. With the 4H pencil, add whiskers and additional fur strokes where necessary. Pick out lighter fur strokes with the eraser pencil, if desired.

raccoon kit

materials

SURFACE

bristol board (vellum)

PENCILS

GRAPHITE PENCILS:

2B

4H

OTHER SUPPLIES

click eraser

craft knife

facial tissue

stylus

tortillions

tracing paper

transfer paper

Raccoons are a common sight in both parks and suburban areas. They quickly adapt to the presence of humans (and especially leftover human food). The combination of a black mask and a habit for stealing food causes many people to think of raccoons as "little bandits." They have thick, bushy fur, especially on the tail, although a baby raccoon has a smaller facial ruff and thinner tail than the adult. The thick fur on the legs ends at the paws, which are dark and covered with short hair on top and hairless on the undersides.

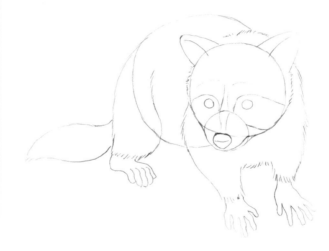

1 Sketch and Transfer

Using a 2B pencil, sketch the raccoon kit on tracing paper, using either the basic shapes method or the grid method. Once you are satisfied with the drawing, transfer it to bristol board. Raccoons have light whiskers, so impress them with a stylus before you begin drawing. (If you do not have a stylus, you can also scratch out the lines with a craft knife in Step 5 if you prefer.)

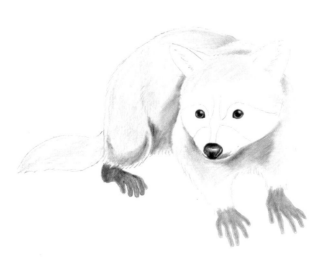

2 Add Tone

Holding the 2B pencil on its side, lightly add tone to the head and body. Press slightly harder to add tone to the feet. Blend with a facial tissue wrapped around your finger. Draw the eyes and nose with the 2B pencil, leaving the highlights as white paper. Soften the highlights with the eraser. Add more shading with a dirty tortillion.

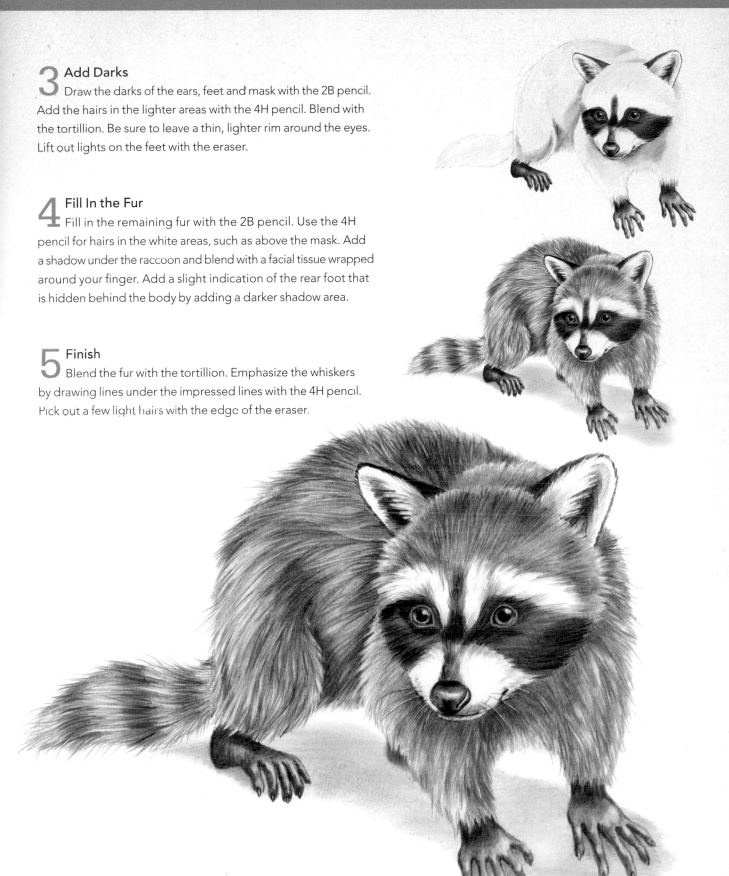

3 Add Darks
Draw the darks of the ears, feet and mask with the 2B pencil. Add the hairs in the lighter areas with the 4H pencil. Blend with the tortillion. Be sure to leave a thin, lighter rim around the eyes. Lift out lights on the feet with the eraser.

4 Fill In the Fur
Fill in the remaining fur with the 2B pencil. Use the 4H pencil for hairs in the white areas, such as above the mask. Add a shadow under the raccoon and blend with a facial tissue wrapped around your finger. Add a slight indication of the rear foot that is hidden behind the body by adding a darker shadow area.

5 Finish
Blend the fur with the tortillion. Emphasize the whiskers by drawing lines under the impressed lines with the 4H pencil. Pick out a few light hairs with the edge of the eraser.

young mouse

materials

SURFACE
Canson Mi-Teintes
paper (white)

PENCILS

GRAPHITE PENCILS:
2B
4H

DERWENT PASTEL PENCIL:
Burnt Sienna

DERWENT STUDIO COLOUR PENCILS:
Chinese White
Copper Beech
Golden Brown
Gunmetal
Ivory Black
Raw Sienna
Rose Pink

OTHER SUPPLIES
craft knife
tortillions
tracing paper
white transfer paper

This drawing is of a juvenile deer mouse. Mice are born with their eyes closed and no fur, and are called "pinkies" when they are newborns. Once open, the eyes are quite round and appear to bulge out from their sockets somewhat when you are looking at the mouse head-on. Mouse tails have varying amounts of hair, but from a distance they look pink and hairless. Mice are quick movers and are good at hiding, so you will be lucky to get a good photograph of one in the wild. (And I hope you never see one in your house!)

1 Sketch and Transfer

With a 2B pencil, sketch the shape of the mouse on tracing paper, using either the basic shapes method or the grid method. The head is egg-shaped and is large in proportion to the body. The eyes are round and bulge from the sockets slightly. Tape your sketch to a window or a light box and tape your drawing paper over the top. The light should shine through, allowing you to see your sketch (you may have to darken the sketch lines). With the Copper Beech colored pencil, trace the sketch.

2 Fill In the Body

Fill in the base fur with the Burnt Sienna pastel pencil, and blend with a tortillion. Leave white areas as shown.

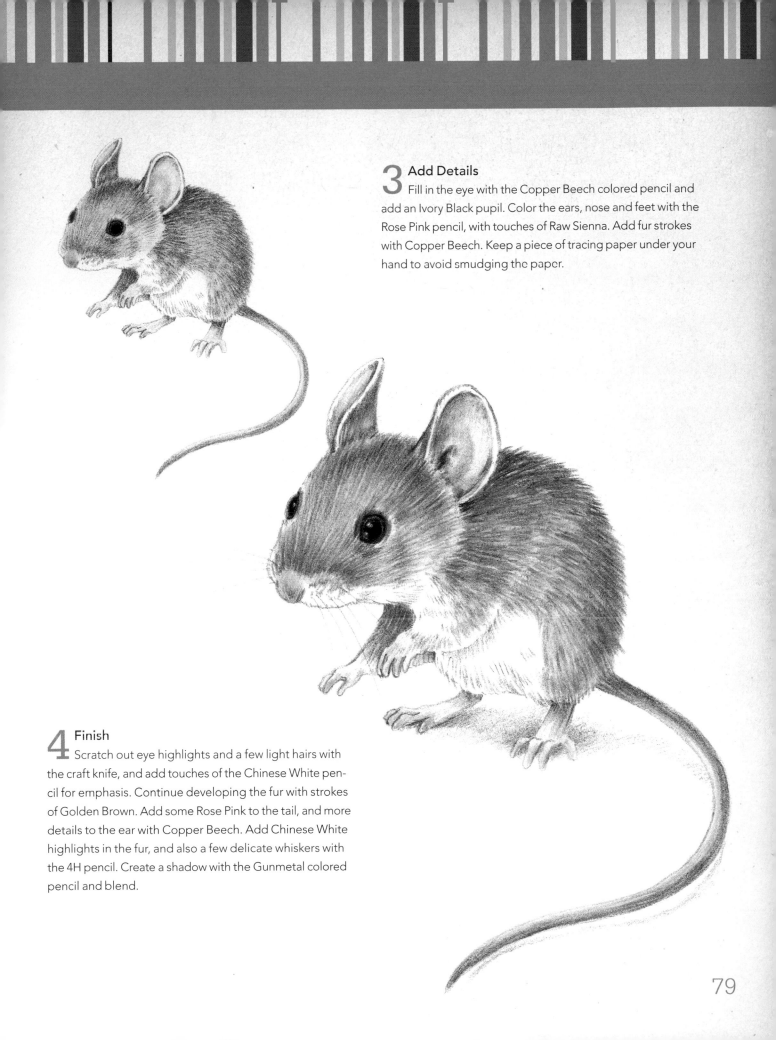

3 Add Details

Fill in the eye with the Copper Beech colored pencil and add an Ivory Black pupil. Color the ears, nose and feet with the Rose Pink pencil, with touches of Raw Sienna. Add fur strokes with Copper Beech. Keep a piece of tracing paper under your hand to avoid smudging the paper.

4 Finish

Scratch out eye highlights and a few light hairs with the craft knife, and add touches of the Chinese White pencil for emphasis. Continue developing the fur with strokes of Golden Brown. Add some Rose Pink to the tail, and more details to the ear with Copper Beech. Add Chinese White highlights in the fur, and also a few delicate whiskers with the 4H pencil. Create a shadow with the Gunmetal colored pencil and blend.

79

fox kit

materials

SURFACE

bristol board (vellum)

PENCILS

GRAPHITE PENCIL:

2B

DERWENT PASTEL PENCILS:

Burnt Sienna

Chocolate

Hooker's Green

Terracotta

DERWENT STUDIO COLOUR PENCILS:

Copper Beech

Golden Brown

Ivory Black

Mineral Green

Terracotta

OTHER SUPPLIES

click eraser

craft knife

facial tissue

small round paintbrush

Titanium White
watercolor paint

tortillions

tracing paper

Red foxes are found in many countries of the world. They have adapted easily to humans, so they may be frequently encountered in suburbs and cities. On the North American continent, there are several other species of foxes: arctic, kit and gray. The adult red fox is known for its bushy, white-tipped tail, but this is less outstanding on a juvenile. The young fox's muzzle is softer in shape and not as pointed as that of the adult. Foxes also have vertical pupils, like those of a cat.

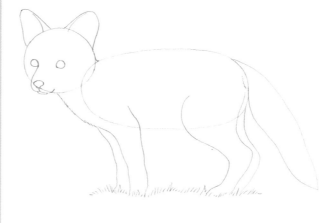

1 Sketch and Transfer

With a 2B pencil, sketch the fox kit onto tracing paper using your preferred method. The fox's head is based on a circle. Tape the sketch to a window (or use a light box) and tape bristol board over the top. The light should shine through, allowing you to see your sketch (you may have to darken the sketch lines). With a Copper Beech colored pencil, trace the sketch, using delicate fur strokes.

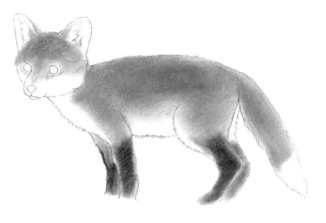

2 Fill In the Body

Fill in the base fur color with a Burnt Sienna pastel pencil and blend with a facial tissue wrapped around your finger. The legs are a little darker, so add a little tone with a Chocolate pastel pencil. Add a smudge of Chocolate pastel to the tail, just above the white fur.

3 Add Details and More Fur

Color the eyes with the Golden Brown colored pencil, and the nose with the Copper Beech pencil. Add Ivory Black details. Begin filling in the fur with the pastel pencils in Chocolate, Terracotta and Burnt Sienna. Leave a light rim along the legs to help define the separation between them.

4 Blend

Blend the pastel strokes with a tortillion. Use separate ends of the tortillion for the light and dark areas. Add highlights to the eyes and nose with the Titanium White watercolor and a small round paintbrush. Add a light layer of grass with the Hooker's Green pastel pencil and blend with a tissue.

5 Finish

Add details to the fur with the Copper Beech colored pencil. Lift out a few highlights with the click eraser. If necessary, cut the end off the eraser with a craft knife to create a sharp edge. Add grass details with the Mineral Green colored pencil.

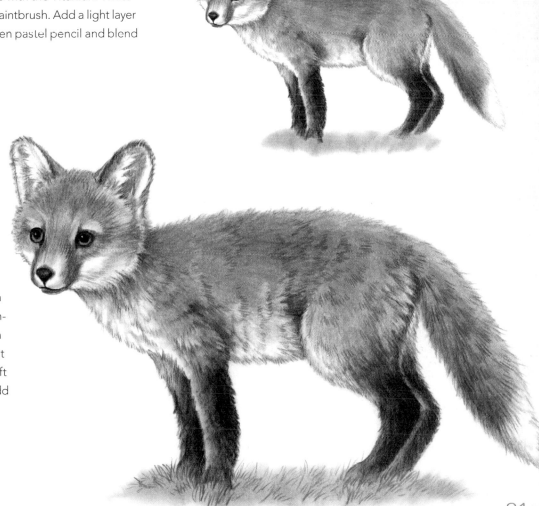

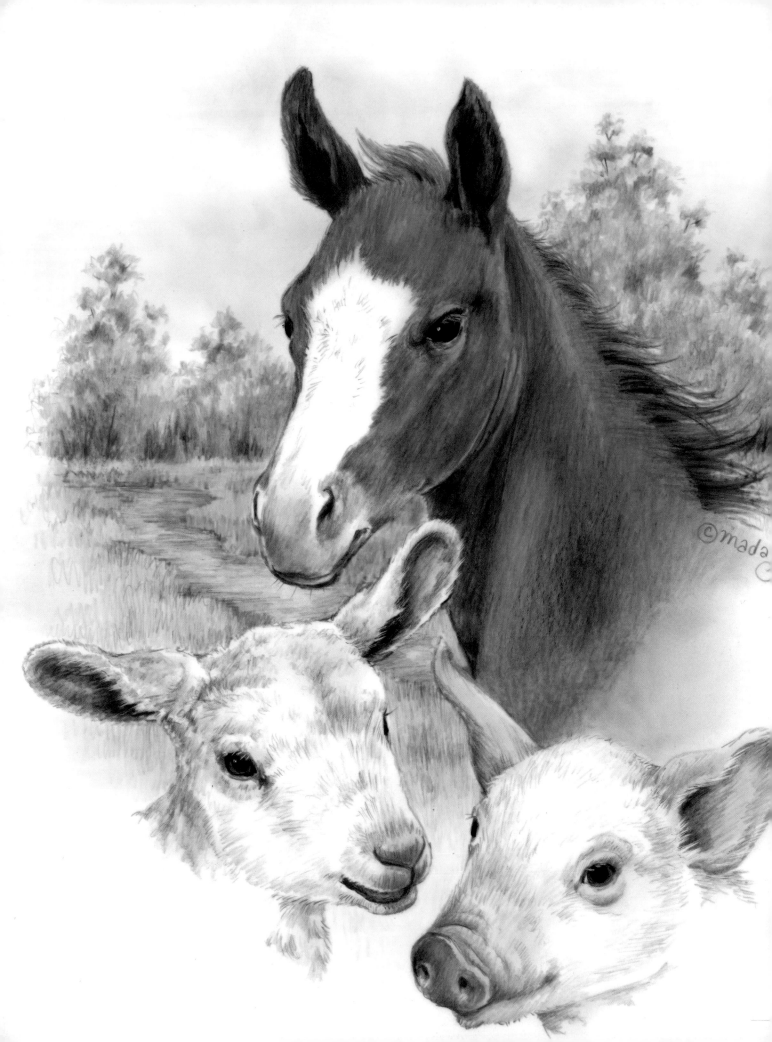

Hooved Mammals

Since prehistoric times, hooved mammals have been an important factor in our lives for both food and hides, and as subjects for works of art. Early man created drawings in caves that show how necessary these animals were for human survival, both physically and spiritually. In this chapter, I focus on both domesticated and wild hooved mammals.

The drawing at left is a montage of some hooved animals you might see on a farm. Working with stick pastels, I filled in the first layers of color for the sky and the grass with medium blues and greens, using sponge applicators to apply the pigment. The soft white clouds were lifted out with an eraser. I added loose foliage to the background trees with olive green colored pencils, and indicated the path with yellow ochre. The foal was filled in with terracotta pastel, and I left the piglet and lamb the white of the paper.

Next, I added colored pencil details to the background with various dark greens and browns, with a little yellow ochre in the grass to warm it up. When creating a drawing with a fairly detailed background, remember to keep things in the distance soft; the only tight detail should be in the foreground.

The foal's shading and details were achieved with dark brown and terracotta colored pencils, leaving the white area as plain paper. Soft pinks and raw sienna were rubbed into the muzzle and blended with a tortillion. The eyelashes overlapping the eye were scratched out with a craft knife.

For the piglet and lamb, I added soft tone with a raw sienna colored pencil and blended with a tortillion. More details were drawn in with a brown colored pencil. The piglet's nose, ears, and around the eyes get their appearance from pink, terracotta, and brown colored pencils.

keys to drawing hooved mammals

Here are some things to keep in mind when drawing hooved mammals such as fawns, foals, lambs and piglets. As with the smaller mammals we looked at in Chapter 5, these animals have great variation in their fur. Lambs have soft wool while piglets have sparse bristles. Hooved mammals have eyes placed far to the sides of their long muzzles.

Piglet Shapes

Piglets have stocky, firm bodies with short legs that end in delicate, cloven hooves with a large dew claw at the back.

Basic Shapes

The animals in this section have sturdy bodies that are based on an oval shape. With the exception of the piglet, they have long, slender legs with prominent knees.

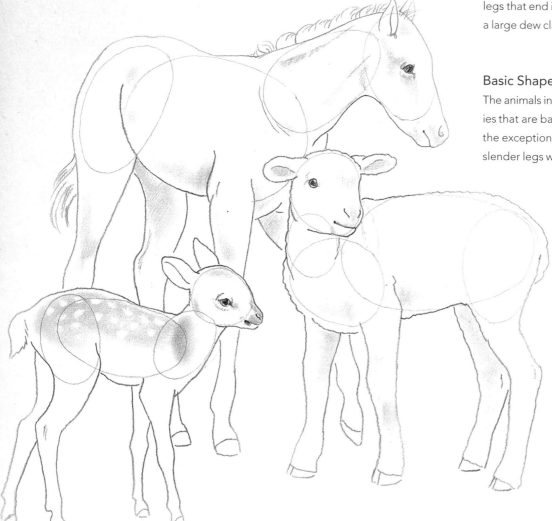

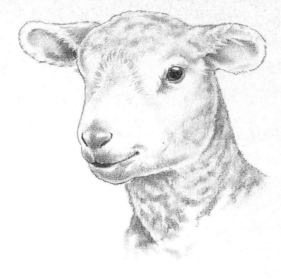

Lamb's Wool—First Steps

Lambs are covered with soft, woolly fleece. A good way to create the texture is to add layers of tone with a pencil or pastel, then lift out areas with an eraser. This image shows the drawing before blending and lifting.

Lamb's Wool—Final Steps

After blending the drawing with a tortillion, lighter areas of fleece can be lifted out by patting with a kneaded eraser.

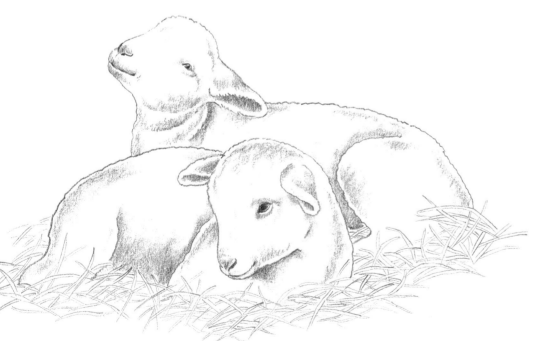

Grouping Animals

Baby animals often sleep cuddled together for warmth. Drawing two or more animals nestled together adds warmth and sweetness to your art.

piglet

materials

SURFACE
bristol board (vellum)

PENCILS
GRAPHITE PENCILS:

2B

4H

OTHER SUPPLIES
click eraser

craft knife

tortillions

tracing paper

transfer paper

Pigs can be a lot of fun to draw. They come in several varieties and colors, such as black Hampshires with a white stripe around their tummies, droopy-eared red Durocs, and white Yorkshires. The overall body shape is the same: flat nose, large ears, long body and short legs. The hair is generally sparse and bristly.

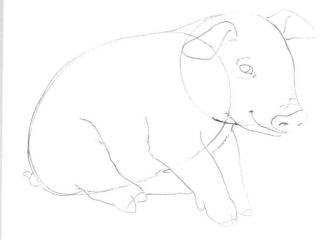

1 Sketch and Transfer
Sketch the basic shape of the piglet with a 2B pencil on tracing paper. Once you are happy with the sketch, transfer only the necessary lines to bristol board. To transfer the design, either use the transfer paper, or tape the drawing to a window with the light shining through (or use a light box), so you can see the design through the paper.

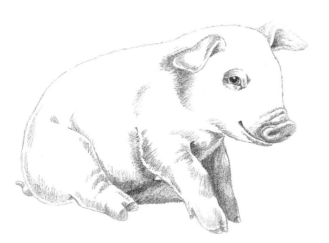

2 Begin Shading
Refine the drawing with delicate strokes of the 2B pencil. Begin adding shading, especially around the eyes, snout and feet.

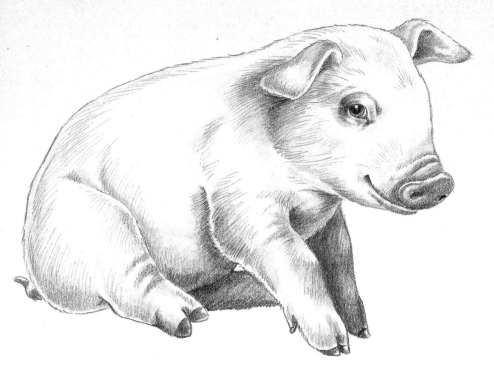

3 Blend

With a tortillion, blend the areas of shading. Use the dirty tortillion to add more shading to areas without pencil strokes. Begin adding sparse hairs with a very sharp 4H pencil.

4 Finish

Cut the end off the click eraser with the craft knife to create a sharp edge. Use the edge to "draw" white hairs with the eraser. With the dirty tortillion, add shading under the piglet to ground him to the page.

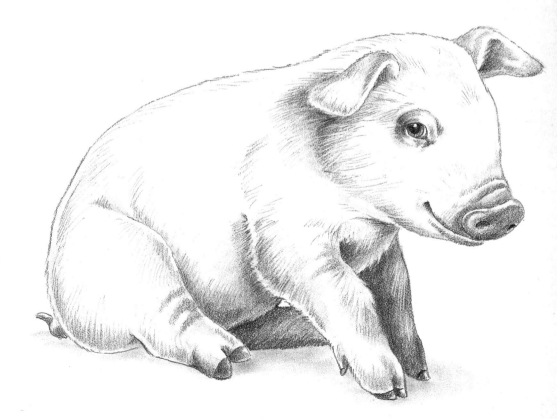

lamb

materials

SURFACE
bristol board (vellum)

PENCILS
GRAPHITE PENCIL:

2B

OTHER SUPPLIES
craft knife

kneaded eraser

tortillions

tracing paper

transfer paper

Lambs have a lot of charm. When I photographed this little fellow at a local farm, he and his twin were frolicking as if they had springs in their legs. Lamb fleece contains an oil called lanolin, which makes it waterproof. This makes the individual hairs bind together, so you will not be drawing separate hairs except around the muzzle. It is helpful to have a tortillion that already has a buildup of graphite for adding tone to some areas.

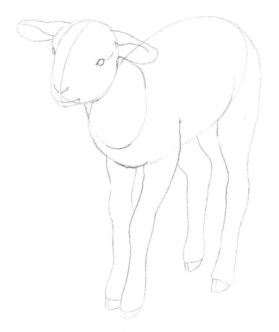

1 Sketch and Transfer
Begin by sketching the lamb onto tracing paper with a 2B pencil, using your preferred method. When the sketch is complete, transfer only the necessary lines lightly onto bristol board.

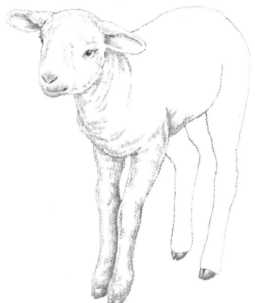

2 Add Tone
Begin adding tone with the 2B pencil, using short, rounded strokes. Use very light pressure for the fleece, and heavier pressure for darker areas such as the eyes. The highlight of the eye should be left as plain paper, or you can scratch it out with the tip of a craft knife.

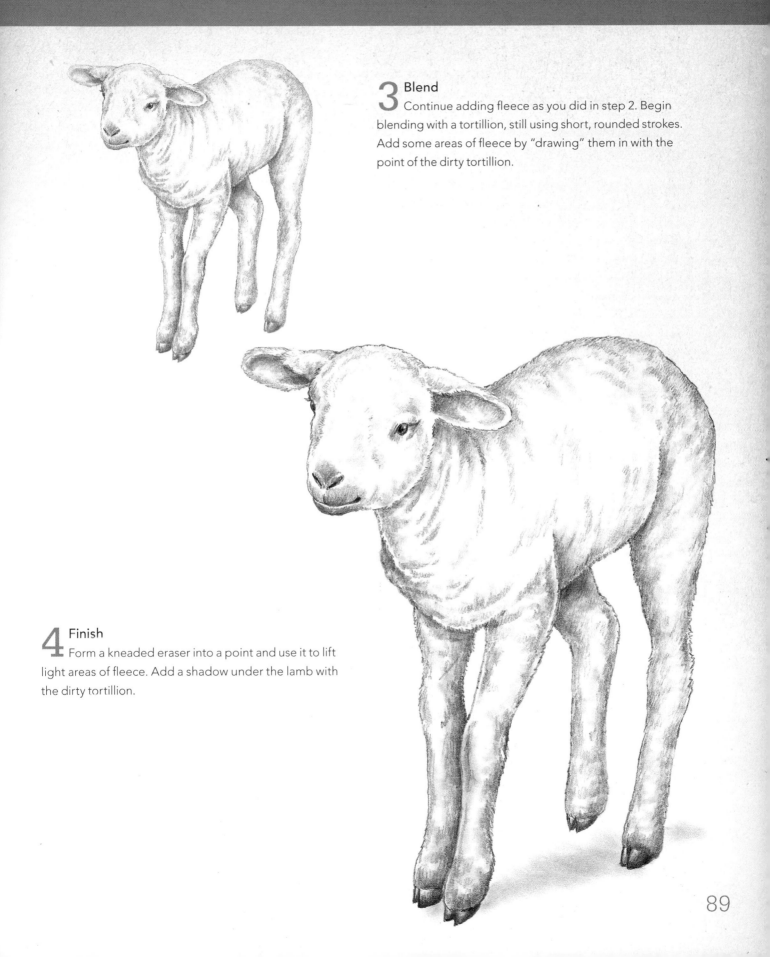

3 Blend
Continue adding fleece as you did in step 2. Begin blending with a tortillion, still using short, rounded strokes. Add some areas of fleece by "drawing" them in with the point of the dirty tortillion.

4 Finish
Form a kneaded eraser into a point and use it to lift light areas of fleece. Add a shadow under the lamb with the dirty tortillion.

foal

materials

SURFACE
bristol board (vellum)

PENCILS
GRAPHITE PENCILS:

2B

4H

OTHER SUPPLIES
craft knife

kneaded eraser

tortillions

tracing paper

transfer paper

A baby horse is called a "foal" until it is a year old. Drawing foals can be tricky, as their heads are larger and their legs slimmer than you might think. Also, their tails are short, compared to the long, flowing tail of an adult horse. The legs can sometimes look awkward and clumsy, but this is part of the appeal of a baby! Horses have glossy coats, so their bodies have more highlights than some other animals do.

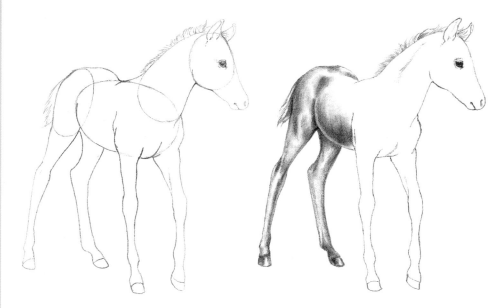

1 Sketch and Transfer
Sketch the basic drawing of the foal with a 2B pencil on tracing paper. Once you are happy with the sketch, transfer only the necessary lines to bristol board. To transfer the design, either use the transfer paper, or tape the drawing to a window with the light shining through (or use a light box) so you can see the design through the paper.

2 Begin Adding Tone
Refine the drawing with the 2B pencil, and begin shading on the left side of the drawing. Blend with a tortillion. Draw the mane and tail with a 4H pencil. Draw the eye with the 2B pencil, leaving the highlight and eyelashes as white paper, or scratch them out with the tip of a craft knife if you prefer.

When shading the belly, leave a light edge. This helps it look round, and helps to separate the belly from the legs.

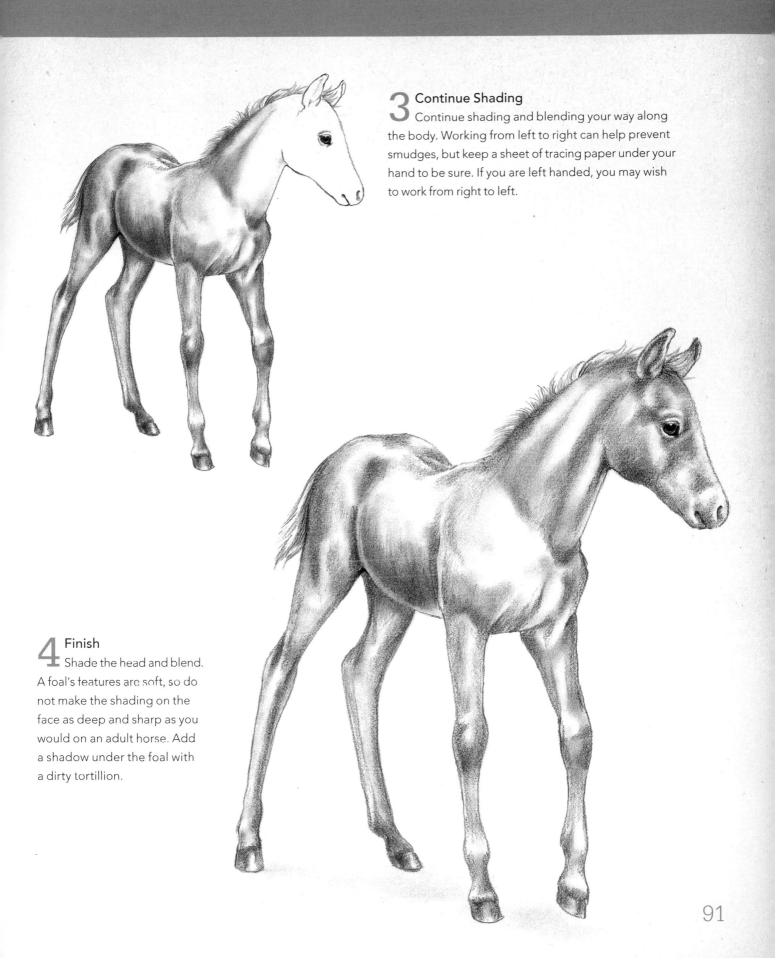

3 Continue Shading

Continue shading and blending your way along the body. Working from left to right can help prevent smudges, but keep a sheet of tracing paper under your hand to be sure. If you are left handed, you may wish to work from right to left.

4 Finish

Shade the head and blend. A foal's features are soft, so do not make the shading on the face as deep and sharp as you would on an adult horse. Add a shadow under the foal with a dirty tortillion.

fawn

materials

SURFACE
bristol board (vellum)

PENCILS

GRAPHITE PENCIL:

2B

DERWENT PASTEL PENCILS:

Burnt Sienna

Chocolate

May Green

Terra Verte

Umber

DERWENT STUDIO COLOUR PENCILS:

Copper Beech

Ivory Black

Mineral Green

Raw Umber

Terracotta

OTHER SUPPLIES

cotton swabs

eraser pencil

kneaded eraser

tortillions

tracing paper

transfer paper

A baby deer is called a "fawn." The characteristic spots on fawns help them camouflage themselves in the dappled sunlight of the woods where they live. Like other young hooved mammals, fawns have long spindly legs with knobby knees.

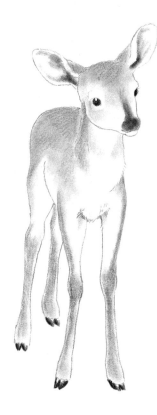

1 Sketch and Transfer
Using a 2B pencil, sketch the fawn on tracing paper, using either the basic shapes method or the grid method. Once you are satisfied with the drawing, lightly transfer only the necessary lines to bristol board. Lift any lines that are too dark with a kneaded eraser.

2 Add Details and Tone
Refine the sketch with the Raw Umber colored pencil. Fill in the eyes and hooves with the Copper Beech colored pencil, leaving the highlights as white paper. Add tone to the fur with the Burnt Sienna pastel pencil and blend with a cotton swab. Use the Chocolate pastel pencil for the nose and inside the ears.

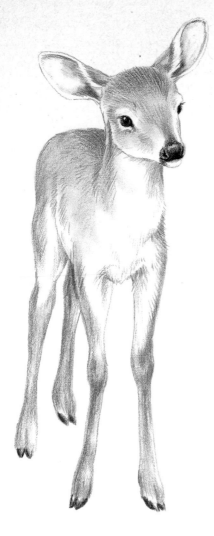

3 Add Form and Shading

Detail the eyes and nose with the Ivory Black colored pencil. Lift out the highlight on the nose with an eraser pencil. Add form and shading to the fur with the Raw Umber and Terracotta colored pencils. Blend with a tortillion.

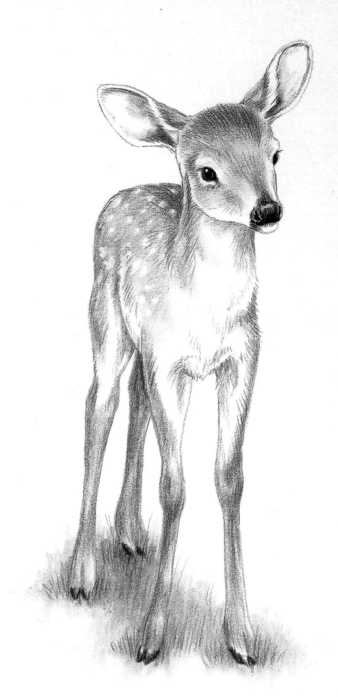

4 Finish

Lift out the white spots with the eraser pencil. Add a bit more shading with the Umber pastel pencil, blending it with a tortillion. Create the grass with the May Green and Terre Verte pastel pencils and blend with a cotton swab. Add a few blades with the Mineral Green colored pencil.

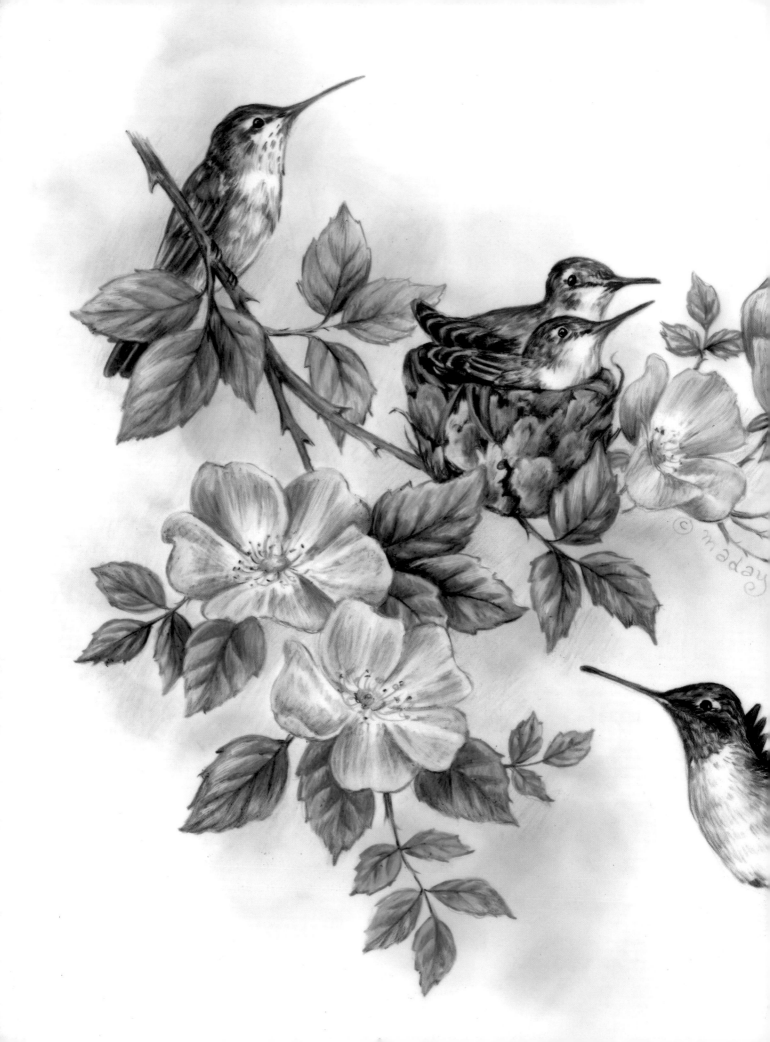

Birds

Birds have been one of the most popular subjects for artists for hundreds of years. Fortunately, now we can work from photographs, unlike artists such as John James Audubon. But if you want to create convincing drawings of birds, it's a good idea to spend some time making quick sketches of them from life so that you have some knowledge of their movement and behavior. I have bird feeders and birdhouses set up around my kitchen window for easy viewing, and I like to spend time at bird rehabilitation centers and zoos.

Spring is the best time to catch a glimpse of baby birds, of course, although some species, like American goldfinches, have their babies in late summer because their favorite food is thistles that have gone to seed.

The hummingbirds at left were great fun to draw. I find their tiny little nests and eggs fascinating. The babies in this picture have grown so big they hardly fit in the nest anymore!

I began the first layer of colors by applying a loose blue and green pastel vignette around the drawing for the background, then erased any areas where the colors overlapped the image. The leaves and flowers received medium green and soft pink, respectively, with colored pencils. The hummingbirds' colors were applied with a blue-green colored pencil, with a little yellow-green around the edges and under the wing. Father bird's chin patch is magenta. The nest is light brown with touches of olive green.

Next, I detailed the leaves with dark green and brown, adding yellow ochre and red along some of the edges. The petals received a few peach colored glazes, then magenta details. The centers are yellow ochre and brown. The nest and twigs were given touches of brown, raw sienna, and olive green.

For the birds, most of the details were drawn with brown colored pencil, but I also added a few turquoise touches, especially on the tail, and a little raw sienna on the breasts. The eyes are black, with a scratched-out highlight. The male's chin patch feathers were drawn in with dark red, with a little brown shading around the edges.

keys to drawing birds

Baby birds are naked and helpless when they hatch. When they have grown some flight feathers and are ready to leave the nest, they are called "fledglings" and this is the stage I find most appealing as subjects for drawing. Here are some things to keep in mind when working on your baby bird drawings.

Beaks

The beak is an important factor when identifying a bird. Many beginning artists make the mistake of drawing a basic triangular beak shape no matter what type of bird they are trying to depict. For example, birds that eat seeds have chunky, sturdy beaks for cracking open the seed casings; insect-eaters have longer, pointed beaks; and nectar-eaters such as hummingbirds have long beaks that act almost like straws.

Eye Position

It can be difficult to get the eyes in the right place when drawing birds. A common mistake is to put the eye in the center of the head. The eye should actually be closer to the beak, as shown in the drawing of a chick (below left).

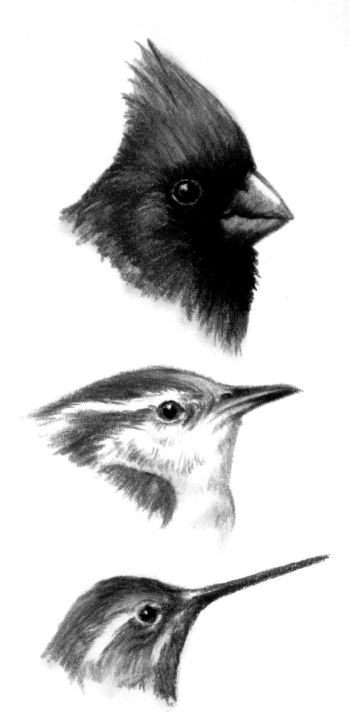

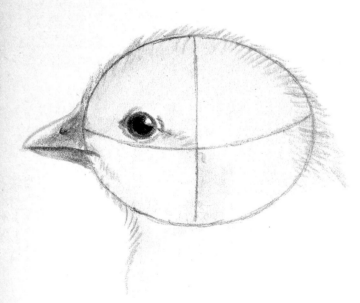

Eye Placement (above)
Include placement guidelines on your initial sketches to help you put the eyes in the correct position.

Diet Determines Beak Shape (right)
The cardinal is a seed-eater. The wren prefers insects. Hummingbirds have long beaks for dipping into flowers.

Sketching

It is very useful to keep a sketchbook of the birds you see. It doesn't matter what your skill level is; a sketch is valuable because it teaches you to really see the bird's behavior and poses. Because birds move so quickly, you will probably create quick gesture sketches rather than tight drawings. If you like any of the sketches, you can go back and add more details later.

Eggs

In this chapter on baby birds, I thought it might be a good idea to include some eggs. Different birds lay different sizes, shapes and colors of eggs. Many people draw songbird eggs as either miniature white chicken eggs or as bright blue robin's eggs, but be sure your bird's eggs have the appropriate color and pattern.

Fledglings

These are some sketchbook drawings of various fledgling baby birds. It's a funny sight to see a fledgling as big as its parent but still begging for food. As the mother of a teenager, I can certainly sympathize! I like drawing fledglings better than newborn chicks because I find the fledgling's scruffy, half-grown feathers more endearing than the newborn nestling's naked skin.

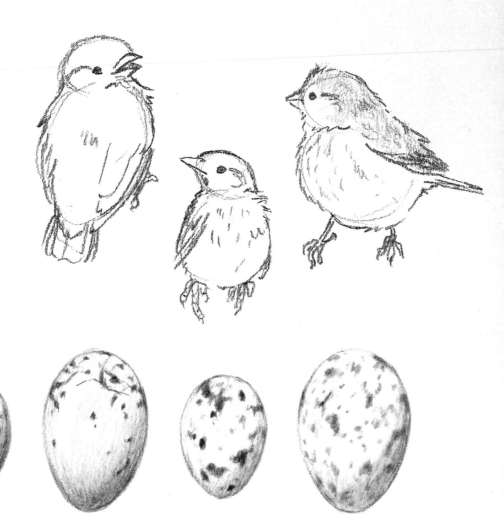

Eggs

These eggs, from left to right, are from a chipping sparrow, a chickadee, a red-winged blackbird, a barn swallow, and a cardinal. Never collect eggs from a nest. You can sometimes find broken shells near the nest after the babies have hatched. Or you can look at specimens at a museum or in a book for reference.

chick

materials

SURFACE
bristol board (vellum)

PENCILS
GRAPHITE PENCILS:
2B
4H
PASTEL PENCIL:
French Grey 70D

OTHER SUPPLIES
click eraser
cotton swabs
craft knife
kneaded eraser
tortillions
tracing paper
transfer paper

When chicks first hatch, they are damp and bedraggled, but within a short time they have the dry and fluffy appearance that we expect. They grow quickly: by two weeks old, they begin developing their adult feathers, and by four weeks their down is almost gone. The chick in this drawing is about ten days old. Some people think that brown eggs are healthier to eat than white eggs, but the only difference is that white eggs come from white hens, and brown eggs come from brown ones. Some hens even lay eggs that are green!

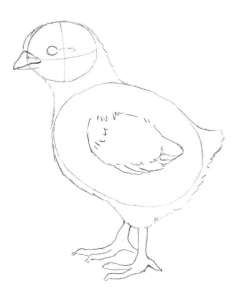

1 Sketch and Transfer
Draw the chick on tracing paper, using a 2B pencil and either the basic shapes method or the grid method. Transfer only the necessary lines onto bristol board. Lift any lines that are too dark with a kneaded eraser.

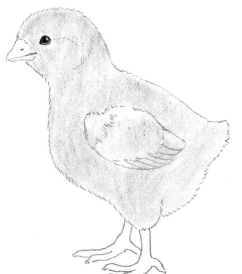

2 Add Tone
Refine the drawing with delicate strokes of the 2B pencil. Fill in tone with the French Grey pastel pencil, and blend with a cotton swab. Draw the eye with the 2B pencil, leaving the highlight as plain paper.

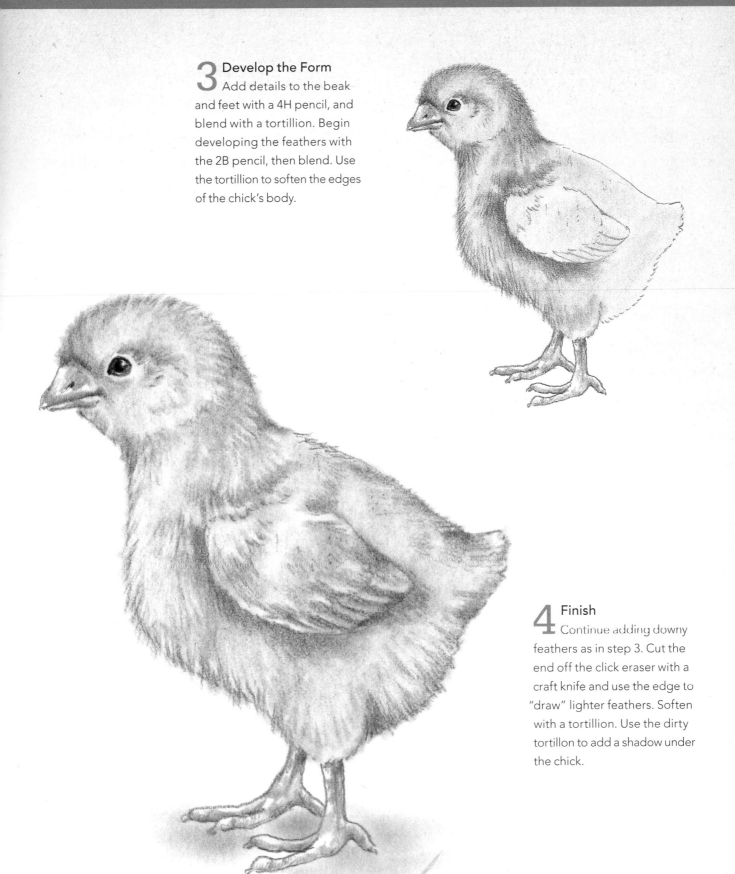

3 Develop the Form

Add details to the beak and feet with a 4H pencil, and blend with a tortillion. Begin developing the feathers with the 2B pencil, then blend. Use the tortillion to soften the edges of the chick's body.

4 Finish

Continue adding downy feathers as in step 3. Cut the end off the click eraser with a craft knife and use the edge to "draw" lighter feathers. Soften with a tortillion. Use the dirty tortillon to add a shadow under the chick.

penguin chick

materials

SURFACE
bristol board (vellum)

PENCILS

GRAPHITE PENCIL:

2B

PASTEL PENCIL:

French Grey 70D

CHARCOAL PENCIL:

dark

OTHER SUPPLIES

click eraser

facial tissue

tortillions

tracing paper

transfer paper

LIFTING COLOR WITH FRESH BREAD

Did you know that when you are working with pastel or charcoal, you can sometimes lift color with fresh bread rather than an eraser, to avoid damaging the surface of the paper?

You are not likely to see a penguin chick in the wild, but I couldn't resist including one. Their soft, dark down is perfect for practicing charcoal techniques.

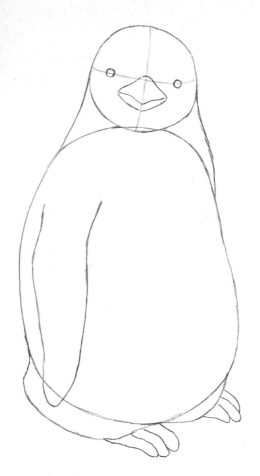

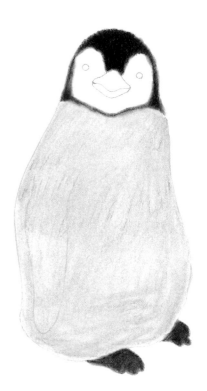

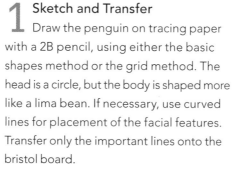

1 Sketch and Transfer
Draw the penguin on tracing paper with a 2B pencil, using either the basic shapes method or the grid method. The head is a circle, but the body is shaped more like a lima bean. If necessary, use curved lines for placement of the facial features. Transfer only the important lines onto the bristol board.

2 Add Tone
Fill in the body with the French Grey pastel pencil, then blend with a facial tissue wrapped around your finger. Don't worry if it isn't smooth, as you'll go over it later. Draw the black area on the head and the feet with the charcoal pencil. Blend with a tortillion.

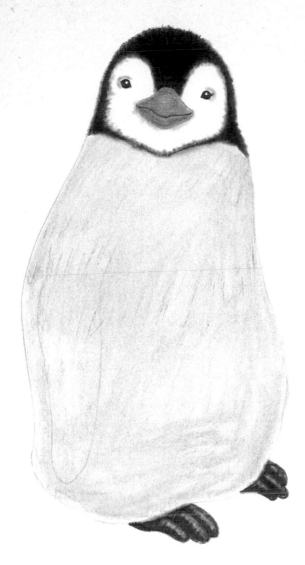

3 Continue Adding Form

Draw the eyes with the 2B pencil, leaving the highlights as white paper. Lightly fill in the beak with the 2B pencil and blend with a tortillion. Use the dirty tortillion to add shading to the face. Lift out highlights on the feet with the eraser, and add dark details with the 2B pencil.

4 Finish

Detail the beak with the 2B pencil, and lift out highlights with the eraser. Shade the body with the charcoal pencil and blend with a tortillion. Use the dirty tortillion to draw the fluffy edges of the body and to add some of the shading. Lift out light areas with the click eraser.

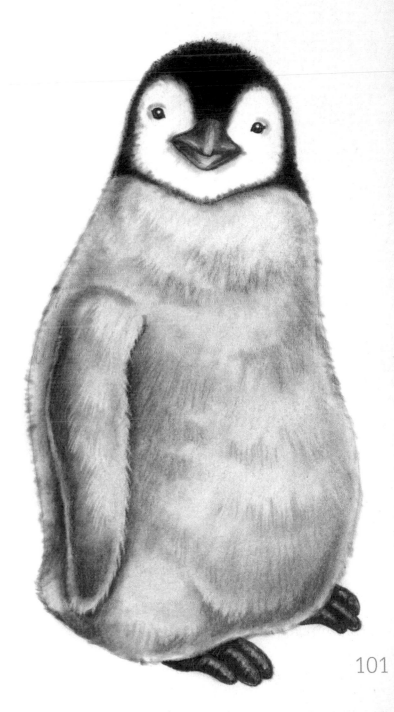

duckling

materials

SURFACE
Canson Mi-Teintes
paper (white)

PENCILS

GRAPHITE PENCIL:

2B

DERWENT PASTEL PENCILS:

Brown Ochre

Chocolate

Deep Cadmium Yellow

DERWENT STUDIO COLOUR PENCILS:

Burnt Umber

Chinese White

Copper Beech

Deep Cadmium Yellow

Golden Brown

Ivory Black

Terracotta

OTHER SUPPLIES

click eraser

cotton swabs

craft knife

kneaded eraser

tortillions

tracing paper

transfer paper

The ducklings of domestic white ducks are completely yellow. I have chosen to draw a mallard duckling, which has distinctive brown and yellow markings that help camouflage it in the wild. All the species of wild ducklings have dark beaks; it is a common mistake to draw them orange as on a domestic duck.

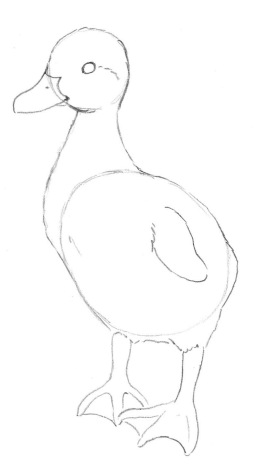

1 Sketch and Transfer

On tracing paper, sketch the basic shapes of the duckling with a 2B pencil. Once you are happy with the sketch, transfer only the necessary lines to the Canson paper, making sure to use the smoother side. Tape the sketch to a window with light shining though, or use transfer paper. Lift any lines that are too dark with a kneaded eraser.

TRANSFERRING WITH COLOR

If you are transferring your drawing by taping your sketch to a window with your Canson paper on top, you can transfer with the Golden Brown colored pencil so you don't have any graphite lines on your final drawing.

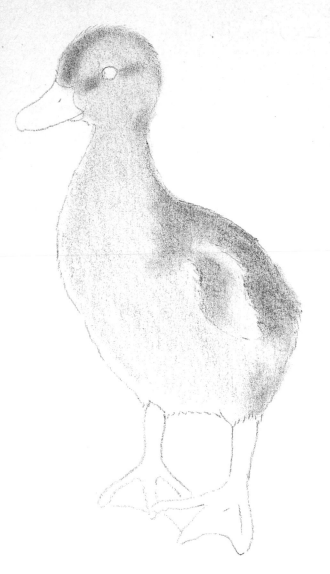

2 Add Base Colors

Refine the drawing with the Golden Brown colored pencil. Lay in the base colors with Brown Ochre and Deep Cadmium Yellow pastel pencils, and blend with a cotton swab. Add the brown areas with the Chocolate pastel pencil and blend.

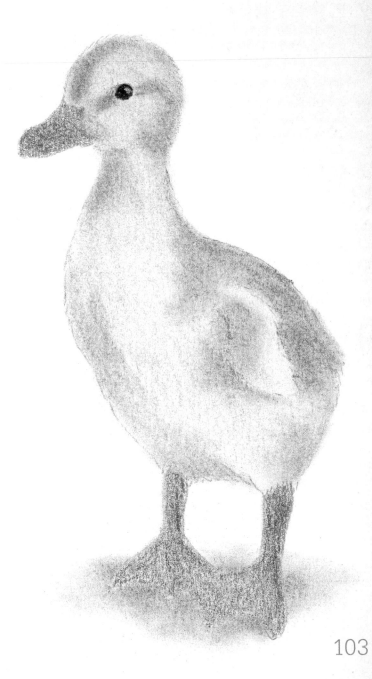

3 Develop the Form

Draw the eye with the Copper Beech and Ivory Black colored pencils. Fill in the beak and legs with the Terracotta colored pencil and blend with a tortillion. Begin shading the body with the Golden Brown colored pencil, then blend with a cotton swab. Add a shadow beneath the duckling with the Chocolate pastel pencil and blend.

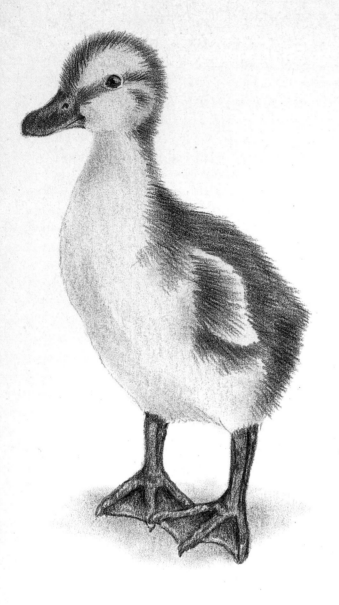

4 Add Downy Feathers

Draw the darker feathers with the Copper Beech and Burnt Umber colored pencils, using short, delicate strokes. Your pencils should be very sharp. Add details to the beak and feet with the Burnt Umber colored pencil.

5 Continue Adding Details

Burnish the beak and legs with Chinese White and add a few more details with Terracotta. Continue developing the feathers with the Golden Brown and Deep Cadmium Yellow colored pencils.

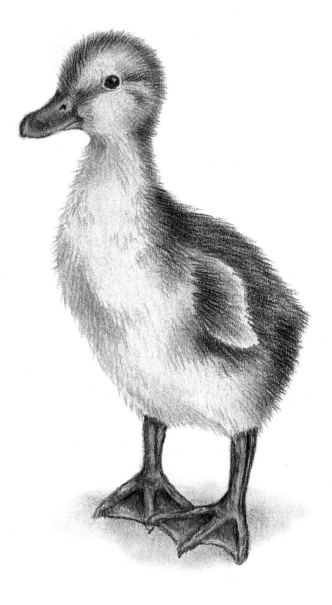

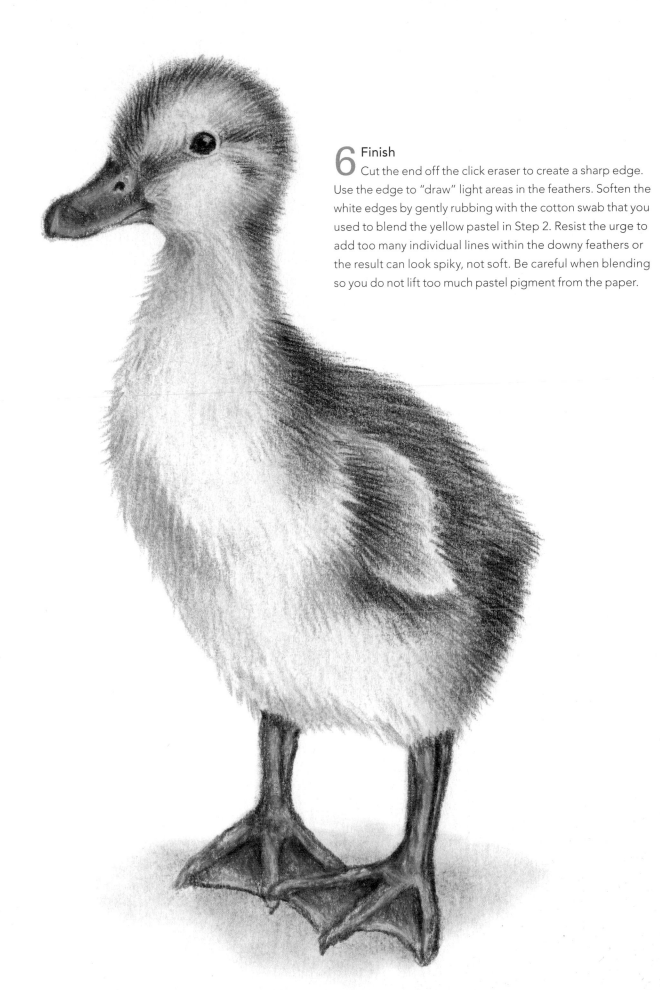

6 Finish
Cut the end off the click eraser to create a sharp edge. Use the edge to "draw" light areas in the feathers. Soften the white edges by gently rubbing with the cotton swab that you used to blend the yellow pastel in Step 2. Resist the urge to add too many individual lines within the downy feathers or the result can look spiky, not soft. Be careful when blending so you do not lift too much pastel pigment from the paper.

baby chickadees

materials

SURFACE
Canson Mi-Teintes
paper (white)

PENCILS

GRAPHITE PENCIL

2B

4H

DERWENT PASTEL PENCILS:

Burnt Sienna

Chocolate

French Grey 70D

Ivory Black

May Green

Spectrum Blue 32F

DERWENT STUDIO COLOUR PENCILS:

Burnt Umber

Chinese White

Golden Brown

Gunmetal

Ivory Black

Lemon Cadmium

Raw Umber

OTHER SUPPLIES
cotton swabs

craft knife

kneaded eraser

tortillions

tracing paper

transfer paper

The black-capped chickadee is a North American bird that is similar to the European coal tit. These birds nest early in whatever holes they can find in tree stumps, fence posts or birdhouses. The mother chickadee has an interesting way of protecting her babies. If an intruder approaches, she puffs herself up with air and blows it explosively in the trespasser's face.

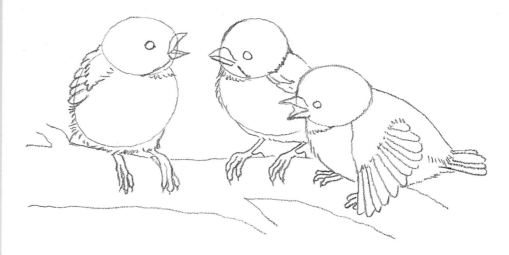

1 Sketch and Transfer
Lay out the drawing of the young birds on tracing paper with a 2B pencil, using either the basic shapes method or the grid method. Fix mistakes and make any necessary adjustments, and when you are happy with the line drawing, lightly transfer only the necessary lines to the Canson paper. Lift any lines that are too dark with a kneaded eraser.

USE A LIGHT TOUCH

When using pastel pencils on a delicate subject like baby animals, do not color too hard. If you get too much pigment on the paper, it will be hard to blend with a cotton swab. It's easier to add more pigment if the color comes out too light than it is to lift pigment that has been applied too intensely.

2 Start Adding Color

Lightly refine the drawing. Add a hint of sky by rubbing a cotton swab across a Spectrum Blue 32F pastel pencil and using the pigment you pick up to "paint" the background. Erase any blue that overlaps the birds. Add color to the tree branch with Burnt Sienna and Chocolate pastel pencils, and blend with a cotton swab.

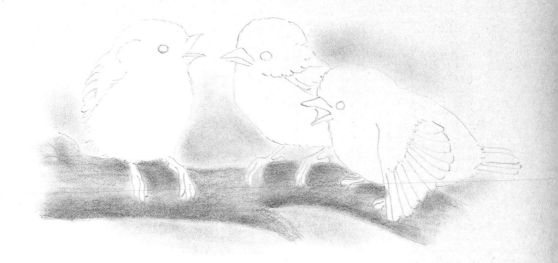

3 Add More Color

Continue adding color with pastel pencils, using French Grey, Ivory Black and Burnt Sienna. Detail the beaks and feet with the Gunmetal colored pencil and blend with a tortillion.

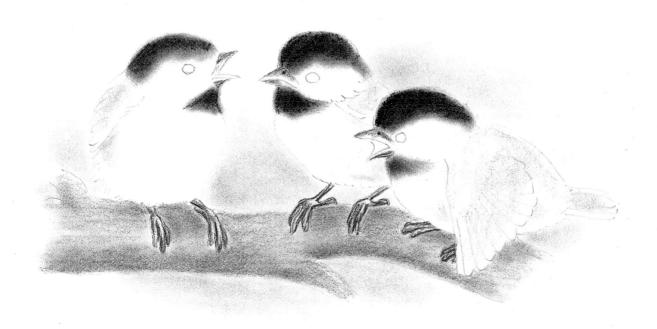

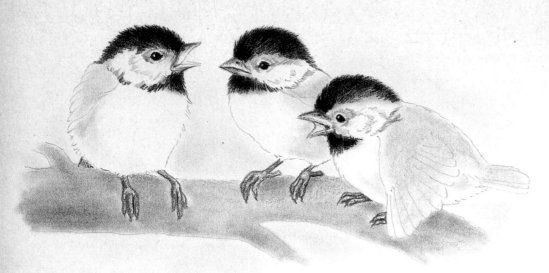

4 Develop the Faces

Draw the eyes with the Burnt Umber and Ivory Black colored pencils, leaving the pupils as white paper. If you accidentally fill in the highlight, scratch it out with the tip of a craft knife. Detail the faces with a 4H pencil. Use the Ivory Black colored pencil to add details to the black feathers on the heads and under the beaks.

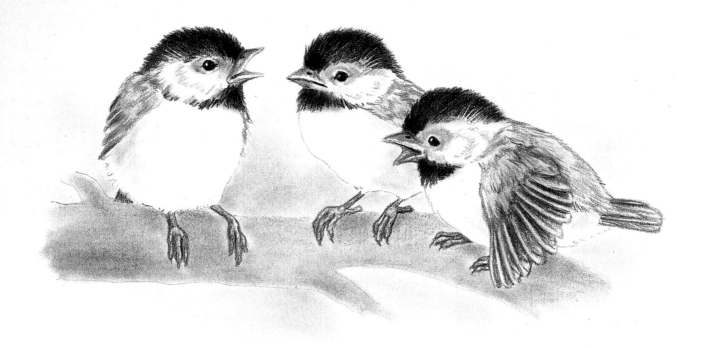

5 Add Feathers

Detail the wings by separating the flight feathers with the Gunmetal colored pencil and burnish with Chinese White. Fill in the beaks with the Golden Brown colored pencil. Scratch out some white wispy feathers on top of the cheeks with the tip of the craft knife. Add touches of green to the background with the May Green pastel pencil and blend with a cotton swab.

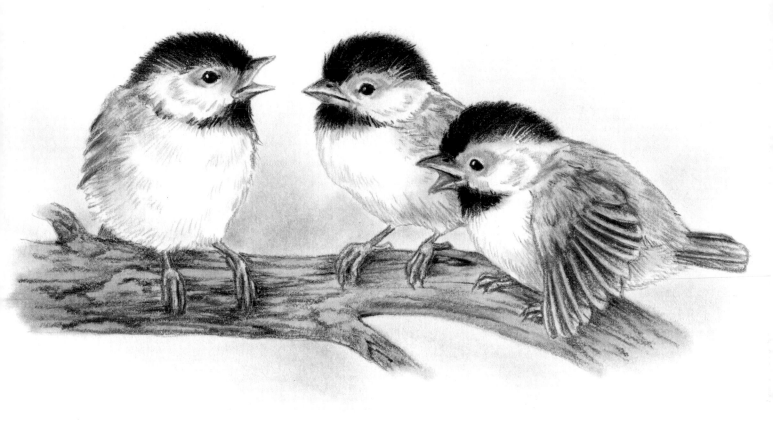

6 Finish

Draw the breast feathers with the Golden Brown colored pencil and the 4H pencil, and blend with tortillions. Scratch out a few white feathers with the craft knife. Add a touch of Lemon Cadmium to the beaks. Detail the tree branch with Burnt Umber, Raw Umber, Gunmetal and Chinese White.

CLOSING THOUGHTS

In this book I have tried to express the enjoyment you can discover in drawing animals. Drawing can be fun, relaxing, and even great therapy! As with most things, the more you practice, the more skilled you'll become. I hope this book has given you a good head-start and that soon you will be drawing your favorite animals with ease and confidence.

index

the best in art instruction & inspiration is from **North Light Books**!